10⁹⁵

DADA

Published in the United States of America in 1987
by Universe Books
381 Park Avenue South, New York, N.Y. 10016

87  88  89  90  91  /  10  9  8  7  6  5  4  3  2  1

Printed in Italy

Library of Congress Cataloging in Publication Data

Lemoine, Serge
Dada

(Masters of modern art)
1. Dadaism. 2. Art, Modern-20th century.
I. Title. II. Series.
N6494.D3L46  1987  709'.04'062  86-27273

ISBN : 0-87663-512-5 (pbk.)

Serge Lemoine

# DADA

Translated by Charles Lynn Clark

## UNIVERSE BOOKS
New York

The elementary repetition of a syllable, evoking the existence of a powerful language prior to articulated speech, Dada has become an almost magical word. It designates one of the most famous and important movements in the history of 20th-century art, a movement that, despite its early demise, radically altered the course of artistic creation in our century.

So much has already been written about Dadaism and its leading figures! It would be superfluous to go into great detail about the myriad individual episodes that punctuated the movement's history as it unfolded in various European and American cities. This information can be found by consulting the standard reference works on the subject, William S. Rubin's *Dada and Surrealist Art*[1] in particular, or more general works on the history of modern art. Poets and writers played an essential role in the development of Dada; but space will not permit us to treat the literary side of the movement in the following pages. We have intentionally limited our study to the plastic arts and focused on analyzing the significance and signification of specific works.

Dada, or Dadaism, sprang up during World War I and, along with Cubism, Expressionism, Constructivism, and Wassily Kandinsky's use of abstraction, became one of the key trends in 20th-century art. Unlike Constructivism, Dada would seem to have been born out of the war itself. Yet, although Dada may be seen as a direct consequence of World War I, it was foreshadowed by a certain number of earlier cultural events; of these, without going back to the Incoherents[2] and Alfred Jarry, the works Marcel Duchamp realized in 1914 and slightly earlier, which so clearly indicate the evolution of his conception of art, were of primordial importance.

A truly international movement, Dadaism was created in Zurich and New York by artists who had fled from the battlefields of their native lands. After the war, some of these artists moved to Germany—Berlin was their usual destination, though a few chose Hanover and Cologne—while others settled in Paris and other European capitals. The movement's originality can be attributed to several factors. First, it was jointly created by artists, poets, and writers working together in total harmony. Second, as a direct

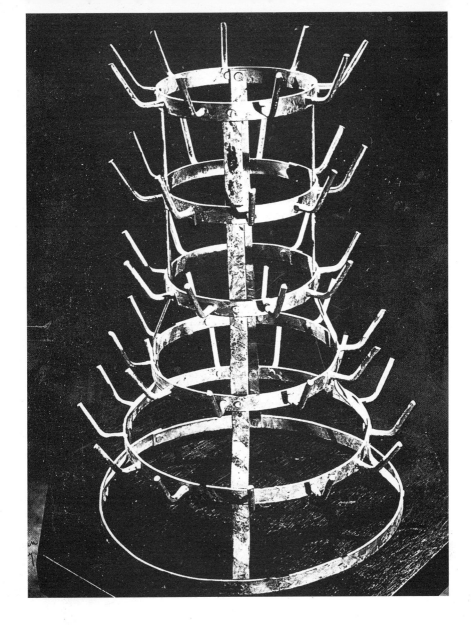

Marcel Duchamp
Bottle Rack
1914

Max Ernst
The Preparation of
Bone Glue
1921

outgrowth of a crisis in Western civilization, its evolution closely paralleled that of international relations as well as that of the political situations found in the individual countries affected by the war. Indeed, some of the movement's major figures, especially in Berlin and Cologne, had close ties with Communist, anarchist, and revolutionary groups. Short-lived though it was (it began in 1916 and died out around 1922), Dada proved to be an exceptionally rich and powerful movement: the Dadaists enormously influenced not only their contemporaries, but later generations of artists as well, and thus played a seminal role in modifying the art and sensibility of the 20th century.

## BEFORE  MARCEL DUCHAMP

Shortly before 1914, as Frank Kupka, Wassily Kandinsky, Piet Mondrian, Kasimir Malevich, and other artists—in the wake of Picasso and Matisse— were beginning to explore the possibilities of nonfigurative painting, and thus, along with Giorgio de Chirico in quite a different way, laying the foundations of 20th-century art, a Cubist painter began a very different kind of exploration. This painter was Marcel Duchamp.

After *Nude Descending a Staircase* (Philadelphia Museum of Art), Duchamp did several more paintings based on the same principle, but with enigmatic or surprising titles that strengthen their odd appeal: *The King and Queen Surrounded by Swift Nudes* and *Passage from Virgin to Bride* (1912, Philadelphia Museum of Art) are highly successful Futurist canvases representing mechanical elements and more or less visceral shapes transformed in a light that is quite reminiscent of Caravaggio.

In a way, everything changed in 1913 when Marcel Duchamp abandoned this approach and used traditional perspective, a sole source of light, and a totally anonymous style to depict an object that would not, *a priori*, seem to be very picturesque: a chocolate grinder. True, the subject is a machine, similar to those that inspired both the Futurists and Fernand Léger; but it is

represented with precision and indifference, *mechanically*, and shows no sign of any artistic interpretation whatever. In this work, Duchamp was contesting the contribution of the Cubists and the early manifestations of nonfigurative art. In 1914, he gave a new version of this theme in *Chocolate Grinder No. 2* (Philadelphia Museum of Art). In the second treatment, the light source has been completely eliminated, and the emphasis is on the painting's anonymous, "machined" aspect (e.g., the real wires sewn onto the canvas to simulate the machine's grooved components). For the title, a machine was used to print gold letters on a piece of leather, which was then glued to the canvas; and this too contributes to the object's industrial look. Marcel Duchamp's goal was to create neutral paintings that would discourage critical commentary because of the very banality of their subject and style while forcing the viewer to reflect on the specificity and function of painting and, more generally, art. Another turning point came when Duchamp abandoned oil painting. He then began creating his "work" out of objects he had not actually made himself, limiting his role to bringing these heterogeneous objects together. In 1913, for example, his *Bicycle Wheel* (the original has been lost) presented the front wheel of a velocipede, the fork of which had been turned upside down and attached to a stool in such a way that the wheel could be freely spun around. Although it most certainly did not resemble any known form of art, the *Bicycle Wheel*, like more conventional artworks, was still the result of an operation performed by the artist who, in this instance, united two elements that were foreign to each other before he intervened.

In 1914, Marcel Duchamp pushed his method to the limit when he went to a department store and bought a galvanized steel bottle rack, which he then signed, dated, and presented as a work of art. With this fundamental act, Duchamp invented the ready-made, i.e., an ordinary object that is, in a sense, "elevated" to the status of artwork simply because an artist chooses to display it as such. This can, in fact, be considered one of the extreme consequences of Picasso's invention of collage.

Indeed, in his artistic activity, Duchamp only seemed to be moving away from Cubism, for his method was basically the Cubist method interpreted in

a particularly radical way. The Cubists would have cut the *Bottle Rack* up and glued it onto a painted canvas. Duchamp, on the other hand, limited his intervention to presenting the object as art. No longer seen in terms of its utilitarian function, the object was thus turned into art simply because the artist chose it and, moreover, displayed it in a place where works of art are exhibited. The ready-made was a radical reflection on the nature of art and led to what was to become the notion of anti-art. It gave rise to fundamental questions about the nature of the subject and construction of a picture, the relevance of the choice of a technique, and the importance of a work's conception. Moreover, it made it possible to reflect on the vanity of artistic creation, on the fact that one solution is as good as another, on taste, and on the way we exhibit and perceive art, which exists in certain contexts, but not in the absolute. Were it taken out of the museum, the *Bottle Rack* would be nothing but a... bottle rack. According to Duchamp, the readymade allowed him to "link the idea of what makes something aesthetic to mental choice, and not to the skill or talent of the artist's hand, which is what I objected to in so many painters of my generation."[3] This somewhat cynical and disillusioned interpretation of the artist's intellectual function had rich consequences for Marcel Duchamp, who eventually abandoned painting, but not artistic creation, and devoted himself to turning his own life and behavior into a work of art. His revolutionary attitude immediately found supporters with the emergence of Dada.

 IN ZURICH

In February 1916, as World War I raged on, Dadaism was invented in Zurich by a German refugee, the poet Hugo Ball, and his companion, Emmy Hennings. They were soon joined by other artists who had moved to Zurich to escape the war: the Romanian poet Tristan Tzara and the German poet Richard Hülsenbeck, the Romanian painters Marcel Janco and Arthur

Segal, the German painters Hans Richter and Christian Schad, the Dutch artists Otto and Adya van Rees, the Alsatian Jean Arp and the Swiss painter and dancer Sophie Taeuber. With the exception of Arp and Taeuber, all of the painters were still using figuration when they came to Dada in 1916, and the general tendency of their works was quite Expressionistic. The group got together regularly in a tavern on the Spiegelgasse, a little street where Lenin was living at the time. The Dadaists transformed this tavern, rechristened the Cabaret Voltaire, into a sort of literary and artistic café where poetry readings, art exhibitions, and all sorts of performances were held.

In 1916, following the example of the *Blaue Reiter* almanach, Hugo Ball launched a journal called *Cabaret Voltaire*. With a handsome cover designed by Jean Arp, the first issue included poetic works by F. T. Marinetti, Blaise Cendrars, Guillaume Apollinaire, and Dadaist writers, as well as reproductions of artworks by Picasso, Modigliani, and the Dadaists. In 1917, following the example set by Jean Arp and Sophie Taeuber, more and more Dadaists began to express themselves using nonfigurative forms, influenced in particular by Kandinsky's abstract works.

These artists were all horrified by the war, which they blamed on Western civilization itself. Turning against their own murderous civilization, they joined forces to form a movement called "Dada," a name they apparently found by opening a dictionary at random.[4] To express their revolt, they organized "anti-artistic" events at the Cabaret Voltaire; these events were principally directed against Western art, which the Dadaists saw as the highest expression of the culture they abhorred. During the "Dada Evenings"—one of which is depicted in a painting of Janco's—poets and painters recited poems, put on theatre-ballet performances, exhibited works of a particularly provocative nature, in form as well as content, and generally tried to create as big a scandal as possible.

Hugo Ball described how the masks that Marcel Janco made for one such occasion were used:

"For our next event, Janco made a certain number of extraordinary masks. They evoked Japanese theatre and Greek tragedy, yet were resolutely modern. Designed to be seen from a distance, they produced an

incredible effect in the relatively small cabaret. We were all there when Janco came in with his masks. And the minute we saw them, we couldn't wait to try them on. When we did, something quite strange happened. Each mask dictated not only what costume should be worn with it, but also certain precise, pathetic gestures, which approached madness. Although we would never have suspected it five minutes earlier, we were soon moving in a bizarre ballet, draped and adorned with incredible objects, trying to outdo each other as we danced around the room.

"The masks transmitted their power to us with an irresistible violence. We understood instantly why such masks are so important for pantomime and theatre, for these masks simply forced anybody wearing one of them into an absurd and tragic dance.

"As we examined these painted cardboard constructions more closely, their ambiguous character suggested various dances to us; and for each of these dances, we immediately composed a little tune. One dance was called the "Flycatcher". With the corresponding mask, the dancer heavily stamped his feet and raised his arms in broad, rapid gestures, as if he was trying to catch something as it flew by, to the sound of a shrill, nervous music. The second dance was called "Nightmare". The dancer emerged from a squatting position and hurled himself forward. The mouth of the mask gaped wide open; the nose was flat and crooked. The dancer's arms, raised in a threatening way, were extended with special tubes. The third dance was "Despair of Celebration". Long, golden hands, cut out of cardboard, were hanging from the dancer's curved arms. The dancer faced right, then left, several times, slowly turned around, and collapsed in utter despair, before returning to the first movement.

"What fascinated all of us in these masks was that they incarnated emotions and passions on a superhuman scale. Suddenly, the horror of our age, against the paralyzing backdrop of the war, was clearly perceptible."[5]

Veritable "happenings" combining all of the many forms of human expression, these events were quite Futuristic in inspiration. And, like the Futurists, the Dadaists aimed to be provocative. Hans Richter remembered

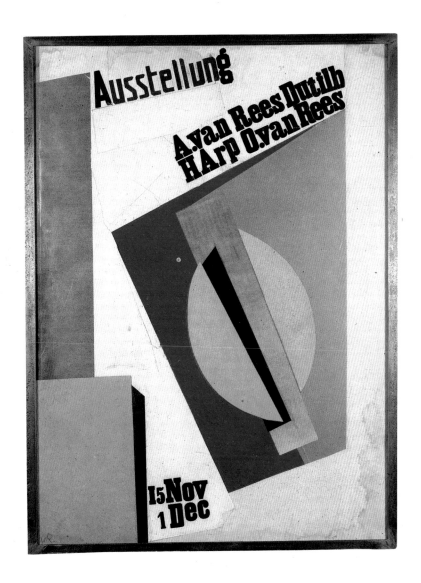

Otto van Rees
Poster
1925

an evening devoted to a reading of phonetic poems (*Lautgedichte*) by Hugo Ball:

"A public reading of abstract poems by Hugo Ball had been announced at our gallery. Arriving a little late, I found the room crammed; only standing room places remained. Ball: 'I was wearing a costume that Janco and myself had designed especially for the occasion. My legs were covered by a sort of bright blue cardboard column that made that part of my body look like an obelisk. Over this, I was wearing an enormous gold cardboard collar lined with scarlet paper, attached around my neck so as to allow me to flap it like a pair of wings by raising and lowering my elbows. The costume was topped off with a magician's hat, a very tall, blue-and-white striped cylinder.

" 'On three sides of the podium, I had set up music stands and placed my manuscripts, written in red, on them; as I recited, I planned to position myself near one or another of the stands. Tristan Tzara knew about my preparations; and we couldn't wait to see what the audience's reaction would be. Everyone else was dying of curiosity to know what I was going to do. Since my column prevented me from walking, I was carried to the podium in the dark, and then began reciting in a slow and solemn cadence:

*gadji beri bimba glandridi lauta lonni cadori*
*gadjama gramma berida bimbala glandri galassassa lautitalomini*
*gadji beri bin blassa glassala laula lonni cadorsu sassala bim*
*gadjama tuffm i zimzalla binban gligia wowolimai bin beri ban*
*o katalominal rhinozerossola hopsamen laulitalomini hoooo gadjama rhinozerossola hopsamen*
*bluku terullaba blaulala looooo...*

" 'This was too much. At first confused by such unfamiliar sounds, the audience finally exploded.'

"At the eye of the storm, Ball remained motionless (he could not move in his cardboard costume) facing the crowd of pretty girls and serious representatives of the middle class as they burst into laughter and applause—motionless like a tower, motionless like Savonarola, uncanny and pure.

" 'As I went on, the accents got heavier and heavier, the sounds grew increasingly intense as the consonants sharpened. I quickly realized that if I

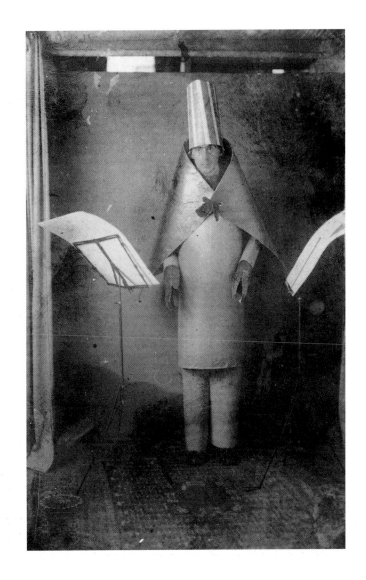

Hugo Ball
at the Cabaret Voltaire
1916

wanted to stay serious—and I did—my expressive means would not be up to the pomp of the staging... I had just finished *Song to the Clouds of Labadas* on the music stand to my right and *Caravan of Elephants* on the left, when I started vigorously flapping my wings and turned to the center. The heavy series of vowels and trailing rhythm of the elephants had just provided a last gradation. But how was I to end ? I suddenly realized that my voice, for want of any other alternative, was taking on the ancestral cadence of a sacerdotal lamentation, the wailing style of the hymns that fill Catholic churches in East and West:

*zimzim urallada zimzim urullala zimzim zanzibar zimzalla zam*
*elifantolim brussala bulomen brussala bulomen tromtata*
*veio da babg bang affalo purzamai affalo purzamai lengado tor*
*gadjama bimbalo glandridi glassala zingtata impoalo ögrogöööö*
*viola laxato viola zimbrabim viola uli paluji maloo*

"'I cannot say what this music suggested to me. All I know is that I began to sing my series of vowels like a kind of liturgical chant; and, as I did so, I tried not only to stay serious myself, but also to impose my seriousness on the audience.

"'For one fleeting moment, I thought I glimpsed, beneath my Cubist mask, an adolescent's pallid, distressed face, the half-scared, half-curious face of a trembling ten-year-old eagerly hanging upon a priest's each and every word during the mass for the dead or some other important mass in his native parish. Just at that moment, the electric light was switched off, as I had requested it be beforehand; and, dripping with sweat, I was carried off the podium to the exit.'"[6]

Considered today, with the notable exception of those of Jean Arp and Sophie Taeuber, the artworks produced by the Zurich Dadaists may seem somewhat disappointing. After his figurative period—which was, for that matter, fairly mediocre—Marcel Janco (1895-1984) was never very convincing with his nonfigurative plaster reliefs and highly Expressionistic woodcuts. Hans Richter (1888-1976) was influenced by Kandinsky, as his rather derivative *Visionary Portrait* (1916-17, Paris, Musée national d'art moderne) shows. Otto van Rees did collages which, though they may have influenced

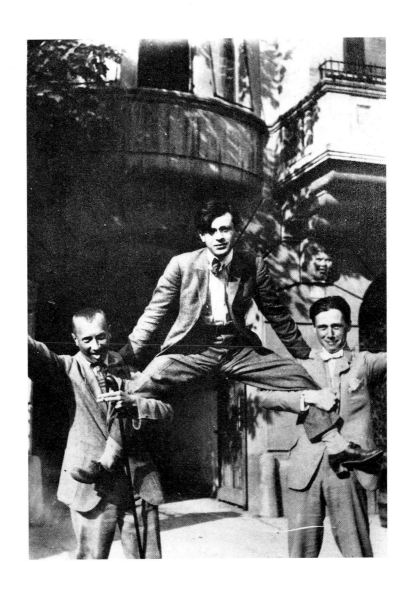

Jean Arp, Tristan Tzara
and Hans Richter
c. 1917-1918

Arp, are not themselves very successful. Arthur Segal (1875-1944) proved more interesting with his use of painted frames around compositions broken up into compartments of equal dimensions traversed by a spectrum of colors (*Port in the Sun*, Zurich, Kunsthaus).

With their collages, paintings, watercolors, engravings, reliefs, and embroidery, Jean Arp (1886-1966) and Sophie Taeuber (1889-1943)—later to become husband and wife—produced the Zurich group's major works. Arp's beginnings were Expressionistic, and show the influence of Kandinsky's *Blaue Reiter* and *Klänge* woodcuts. Taeuber came from the world of the dance, but also had a background in the decorative arts. Already in 1914, Arp, who was born in Strasbourg and had received part of his training in Germany, was exploring the possibilities of nonfigurative collage: *Papier collé* (1915, Bern, Kunstmuseum) shows the influence of Cubist aesthetics in the choice of materials, but the composition is much closer to Kandinsky.

Arp soon transposed this particular combination of materials and compositional tendencies to the polychrome relief. In *Abstract Configuration* (1915, Teheran, Museum of Modern Art), various elements of the same thickness are arranged in two levels on a wood panel. The shapes are geometric, but the overall design is quite free. *The Burial of the Birds and Butterflies* (1916-17, Zurich, Kunsthaus) illustrates much the same idea. Three levels of wood are held together by exposed screws; the irregular forms are smoothly painted (without any visible brushstrokes) in a highly restrained color range (black, dark red, and white-speckled black), but are not attached to a rectangular support. The relief's irregular silhouette stands out directly against the wall, as it also does in *Dada Relief* (Basel, Kunstmuseum), which dates from the same period. It is thus no exaggeration to credit Arp with the invention of cut-out form. In a different vein, the artist also did collages of "neutral" pieces of paper, using more or less regular squares and rectangles cut out of gray, blue, and brown wrapping paper; his 1916 *Geometric Collage* (Paris, F. Arp Collection) is a good example of this approach. Building on these investigations, and eager to experiment with new techniques, Arp turned to embroidery (*Pathetic Symmetry*, 1916, Paris, Musée national d'art moderne); he also did collages whose composition,

Arthur Segal
Port in the Sun
1918

i.e., the arrangement of the forms, was left entirely to the intervention of chance. In *Elementary Construction According to the Laws of Chance* (1916, Basel, Kunstmuseum), each piece of paper was, in theory, chosen at random and then randomly placed on the support. As defined by the Cubists, the *papier collé* had limited the artist's role to arranging elements; Arp went even further and eliminated the traditional "artistic" notion of arranging forms in relation to each other. On this subject, Arp declared: "In 1915, Sophie Taeuber and I did our first works based on the simplest possible forms in painting, embroidery, and collage. These were probably the earliest manifestation of a new kind of art. These works are Realities in themselves, without meanings or cerebral intentions. We rejected everything having to do with copying and description to leave Simplicity and Spontaneity in complete liberty. Since the arrangement of surfaces, as well as their proportions and colors, was left to chance alone, I said that these works were arranged 'according to the law of chance' found in nature, chance being for me but a tiny part of a greater order which, elusive and inaccessible, cannot be wholly grasped. Russian and Dutch artists who were at this time producing works that seemed to resemble our own fairly closely were, in fact, following quite different intuitions. Indeed, their works, unlike our own, are a tribute to modern life, a declaration of faith in the machine and technology. Although they made use of abstraction, these artists were still drawing on naturalism and *trompe-l'oeil* to some extent."[7]

In 1916, Sophie Taeuber began to do nonfigurative drawings, watercolors, and embroideries dominated by horizontal and vertical structures, in reds, blues, and yellows, arranged in two-dimensional space. Her investigations along these lines led to the creation of a masterpiece, the *Vertical-Horizontal Composition with Reciprocal Triangles* (1918, Zurich, Kunsthaus), a triptych consisting of three identically-sized panels structured in vertical strips which intersect with several horizontals to define surfaces painted in black, brown, various shades of red (from orangey to pinkish), blues, and golds. The orthogonal grid is disturbed in the upper section of each panel by two isoceles triangles that add a dynamic emphasis to the whole. In size, composition, and color, this painting does, on some levels, evoke the style of Gustav Klimt's works. Sophie Taeuber soon transposed the aesthetic prin-

From top to bottom:
Jean Arp and Sophie Taeuber, Pathetic Symmetry, 1916-1917.
Jean Arp, The Burial of the Birds and Butterflies, 1916-1917.
Jean Arp, Geometric Collage, 1916

Jean Arp
According to
the Laws of Chance
1916

ciples found in her paintings to sculpture. Her *Portrait of Jean Arp* (1918-1919, Paris, Musée national d'art moderne) is a polychrome "head" in turned wood. She also transposed them to the applied arts and, in 1918, made a puppet theatre for Carlo Gozzi's play *Le Roi-Cerf*. That same year, she and Arp did two collages based on checkerboard patterns; pieces of colored paper were cut into rectangles with a guillotine, then chosen and arranged at random. *Duo-Collage* (Berlin, Nationalgalerie) was thus, in 1918, one of the most radical works ever made, based as it was on a total absence of composition, artistic technique, and sensibility. On this subject, Arp declared: "In December 1915, when I met Sophie Taeuber in Zurich, she had already freed herself from the bonds of traditional art. We began by eliminating everything that was merely a matter of entertainment or taste from our investigations; even the personal touch struck us as useless and embarrassing, for it was the emanation of a dead and rigid world. We looked for new materials on which the curse of tradition had not yet been cast. Working together or separately, we applied ourselves to embroidering, weaving, painting, and glueing together static geometric forms. The result was severe, impersonal constructions consisting only of surfaces and colors. Nothing was overlooked. The slightest spot, crack, or imprecision would have destroyed the purety of a work. For our cut-outs, we even stopped using scissors because they too easily betrayed the presence of a living hand. Instead, we used a guillotine. In the large embroideries, weavings, paintings, and collages we did together at that time, we humbly tried to draw closer to the pure radiance of the real. I think these explorations should be called the art of silence. For they show what happens when art turns away from the outer world and enters into silence, inner being, the real. We used our squares and triangles to transmute the deepest suffering and greatest joy into an architecture of light. Our goal was to make the world simpler, to transform it, to make it more beautiful."[8]

The Dadaist works made by Arp and Sophie Taeuber between 1915 and 1918 are, for fairly obvious reasons, among the first that can be attached to the trend of nonfigurative constructive art.

In 1917, the Cabaret Voltaire having been forced to close down, a Dada

gallery was opened on Zurich's main street, the Bahnhofstrasse. In this new setting, the group continued its activities and exhibited the works of the *Sturm*[9] painters and, a bit later, of Wassily Kandinsky and Paul Klee. At this time, the art and literature review *Dada*, edited by Tristan Tzara, was launched. It folded after four issues, the last published in 1919. In the *Dada Manifesto* published in the third issue (1918), Tzara proclaimed: "Dada means nothing!"

The Dadaists' nonsensical or incoherent poems printed in particularly unusual and inventive typographies[10]—e.g., Ball's *Karawane* (1917) and Tzara's *Bilan* (1919)—their unbearably disorganized performances and "events," their artworks in plaster, embroidery, painted wood, and scraps of paper which represent nothing at all, their publications, pamphlets, posters, and reviews—everything the Dadaists did and made was meant to "sound the alarm against the decline of values and rise of routine and speculation, and rally all artists together in order to establish a new creative base."[11] This attempt by Janco to define Dada's aims was developed in a much more radical way by Hugo Ball: "What we call Dada is a game of madmen dancing like doomed gladiators in the void; it is a game played with the pathetic remains of our civilization... and an execution of so-called morality."[12] By rejecting human feeling in favor of total irrationalism in art and literature, recognizing chance as a factor in creation (assimilated by Richter to the Freudian "subconscious"), defending laughter, and attempting to scandalize at any cost, the Dadaists ridiculed the traditional image of art as the highest form of human expression. They broke down the barriers separating the various modes of expression and replaced the traditional fields of artistic endeavor by interdisciplinarity: the poet became a typographer, the painter a poet... The Dadaist could not be bound to any one technique or type of expression. In a sense, this scrambling of traditional categories expressed an opposition to the established order.

After the Armistice, there being no reason for these artists to stay on in Zurich, most of them moved to Berlin, though some went to Cologne and Paris.

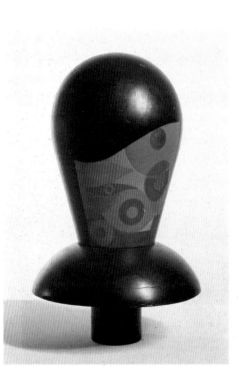

Sophie Taeuber
Portrait of Jean Arp
1918

Sophie Taeuber
Vertical-Horizontal Composition
with Reciprocal Triangles
1918

 IN NEW YORK

As Dada emerged in Zurich, an identical movement was taking shape in New York. Advancing arguments similar to those of their Zurich counterparts, exiles such as Marcel Duchamp and Francis Picabia brought the spirit of Dada to America. A sign of things to come, Marcel Duchamp had, as we have seen, expressed his scepticism regarding traditional art in *Chocolate Grinder*. Already in 1914, Duchamp's ready-mades *Bicycle Wheel* and *Bottle Rack* had proclaimed the dual message that art is dead and the artist alive.

Continuing along similar lines, Duchamp exhibited new ready-mades: a snow shovel entitled *In Advance of the Broken Arm* (1915), a ball of string hiding an object wedged between two copper plates held together by nuts and bolts (*With Hidden Noise*), an advertisement for an enamel company, *Apolinère Enameled*, showing a little girl painting, the text of which the artist modified to turn it into a homage to the poet Guillaume Apollinaire and an allegory of painting. Like the artist's earlier strokes of inspiration, these works can be considered as "pre-Dadaist" creations. Duchamp's most provocative act came in 1917 when he submitted a porcelain urinal to the Society of Independent Artists Show; to be exhibited at a 90° angle, *Fountain*, signed "R. Mutt" and dated "1917," was, needless to say, refused. In all of his anti-aesthetic undertakings, as he struggled against the idea that art is sacred, Marcel Duchamp revealed an attitude that was strictly identical to that of the Zurich Dadaists. Influenced by Duchamp and his *Chocolate Grinder*, Francis Picabia (1879-1953) began a series of works in 1916 that were inspired by industrial drawing and the machine world (e.g., *Run Faster! Machine*, New York, private collection; *Paroxym of Pain* [sic], Paris, Simone Collinet Collection). His absurd images cast suspicion not only on the modern world of industrial machines and progress, but also, particularly due to the texts and titles included in his compositions, on painting

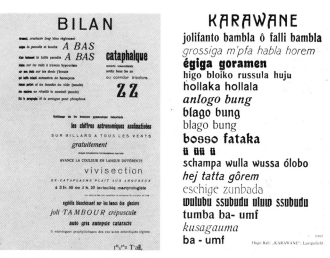

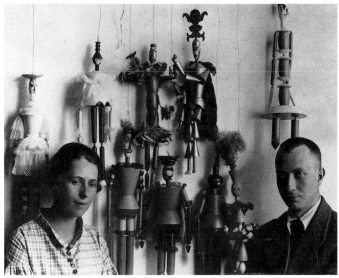

Top:
Tristan Tzara
Bilan, 1919
Hugo Ball
Karawane, 1917

Bottom:
Jean Arp and Sophie Taeuber
Roi-Cerf
1918

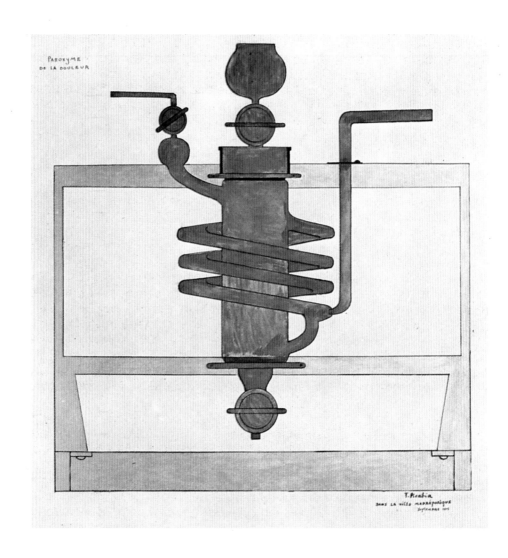

Francis Picabia
Paroxysm of Pain
1916

and language. In *Universal Prostitution* (New Haven, Yale University Art Gallery), he freely represented an electric machine with two components —one male (?), the other female (?)—connected by wires. Various words that the artist wrote on the canvas make the image even more absurd and incomprehensible: "To invite/ to ignore/ human body/ ideological female sex/ overnight bag."

Duchamp and Picabia were joined by other European artists, most notably the painters Albert Gleizes and Jean Crotti, the writer Henri-Pierre Roché, the poet-boxer Arthur Cravan, and the musician Edgar Varèse. The movement also attracted American painters such as Morton Schamberg, Arthur Dove, and Man Ray, all of whom were greatly influenced by Duchamp and Picabia. This influence is quite obvious in, for example, Schamberg's astonishing assemblage *God* (1918, Philadelphia Museum of Art), a three-dimensional transposition with ready-made objects of Duchamp's and Picabia's machine paintings. Working in a similar spirit, Man Ray, after his early Cubist attempts, soon got interested in photography and, in 1919, continuing in the vein of Duchamp's *Chocolate Grinder* and *Bottle Rack*, exhibited a photograph of a vegetable mill and shadow entitled *Man*. In addition to this group of artists, two other figures should be mentioned: the extremely rich New York collector Walter Arensberg and the photographer Alfred Steiglitz, who organized exhibits of these artists' works at his "291" gallery, located at 291 Fifth Avenue. The New York artists also put out several reviews—*291*, Marcel Duchamp's *The Blind Man*, Man Ray's *TNT*—in which they published their own works.

Picabia did not wait for the war to end to return to Europe and, in 1917, launched the review *391* in Barcelona. After the Armistice, the other Europeans, along with Man Ray, settled on the Continent, where they established very close ties with the Dadaists. The New York movement did not, however, die out completely, thanks in large part to the *Société Anonyme*, founded by Katherine Dreier and Marcel Duchamp in 1920, which was to put together one of the 20th century's most outstanding collections of contemporary art.[13]

# DADA IN BERLIN

Forerunners of Dada were found in Berlin as early as 1916. The reviews *Neue Jugend* (New Youth), edited by the Herzfelde brothers, and *Die freie Strasse* (The Free Street), edited by Raoul Hausmann with the collaboration of Johannes Baader, were important precursors of Dadaism in Berlin. In 1917, Richard Hülsenbeck came back from Zurich. These Berliners were soon joined by other German and foreign-born artists to create a Dada movement in Berlin. German Dadaism cannot be separated from the political and social context of postwar Germany. Acutely sensitive to the political collapse of the country and the horrifying aftermath of the war—the dead, the wounded, the disabled, and the starving, unemployed masses—Berlin Dada was anti-Prussian, anti-bourgeois, and anti-capitalistic from the start. Siding with the Spartacist revolutionaries, the Dadaists strongly opposed the creation of the Weimar Republic; and their strong political commitment determined all of their activities. Artistically speaking, even if they denied it, these artists had all been influenced by Expressionism, and some by Cubism and Futurism; after 1920, they were heavily influenced by Giorgio de Chirico. Throughout their history, they used the collage technique they had inherited from Cubism; and, eventually combining this technique with photography, they excelled in photomontage.

The leaders of the "Berlin Dada Government," all of whom had adopted official-sounding titles to mock the organization of society, were Richard Hülsenbeck, the "Welt-Dada" (World Dada), who created a big stir in 1920 when he published his *Dada Almanach*, and the painters Raoul Hausmann, "Dadasopher," George Grosz, "Marshal Dada" or "Propagandada," Johannes Baader, "Dada Superior," and John Heartfield; the group also included Hannah Höch, Hans Richter, Viking Eggeling, Paul Citroën, Arthur Segal, Rudolf Schlichter, Georg Scholz, and Otto Dix.

Following the example of the Zurich artists, the Berliners formed a "Dada

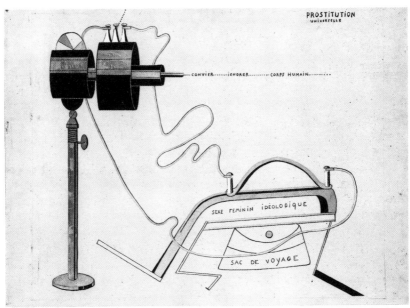

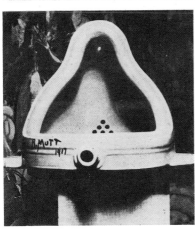

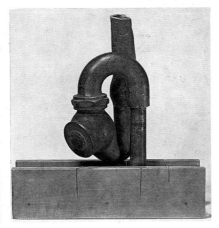

Top:
Francis Picabia
Universal Prostitution
1916

Bottom left:
Marcel Duchamp
Fountain
1917

Bottom right:
Morton Schamberg
God
1918

Club" in 1918 and began publishing reviews such as *Die Pleite* (The Plague). In June 1919, Raoul Hausmann launched the review *Der Dada*, particularly remarkable for its innovative typographical presentation. In April 1918, Hülsenbeck published a manifesto that contributed largely to the diffusion of Dadaist ideas. All of the Berlin artists were politically involved. They took part in public demonstrations, distributed pamphlets, and organized controversial exhibitions, the most important of which was the Erste Internationale Dada Messe (First International Dada Fair). Organized in 1920 at the Burchard Gallery, the Dada Fair included paintings, collages, and sculptures by the main Dadaists, numerous posters and tracts containing provocative slogans, and, hanging from the ceiling, a mannequin dressed in a Prussian officer's uniform, its face hidden by a mask of a pig's head. A sign attached to the dummy announced: "Hung during the revolution."

It is not their political activism, however, but rather the quality and diversity of the works they created that explains the place the Berlin artists made for themselves in the history of modern art.

Raoul Hausmann (1886-1971) was one of the movement's most important figures. He was both a painter and theorist,[14] but also a "sculptor," photographer, editor, typographer, and poet. He was one of the first writers to compose "abstract" poems out of sound, onomatopoeia, and isolated letters arranged on posters. *F M S B W* (Paris, 1918, Musée national d'art moderne) must be recognized as the first utterly meaningless poem; conceived as a poster to be put up around the city, it contains nothing but consonants. Yet, fascinating as it is, Hausmann's work is rather limited. As a painter, he is remembered for his systematic use of collage. His *Synthetic Cinema of Painting* (1918, private collection), originally used as the frontispiece for a manifesto, combines photographs, cigare bands, and a piece of cloth in a composition that completely breaks with Cubism. If *Gurk* (1919, private collection) shows only a head composed out of pieces of newspaper cut into strips, in *The Art Critic* (1919, London, Tate Gallery), where a motif is also isolated against a background, the subject itself is of primordial importance.

Realized in 1920, *Tatlin at Home* (current whereabouts unknown) shows the direct influence of Giorgio de Chirico, whose work the Berlin Dadaists

were then discovering in *Valori Plastici*. Hausmann's style changed radically in this work, which combines collage and traditional techniques in a "metaphysical" space. The work is also a homage to the Russian Constructivist artist Vladimir Tatlin, whose works, not yet known in Berlin, Hausmann and other German artists had formed an idea of from Constantin Umansky's book on Russian art, which had just been published in Berlin.[15] The Berlin artists considered Tatlin to be the inventor of machine art, which explains the images of machine components in the figure's head and the upper right-hand section of Hausmann's collage. The combination of "metaphysical" iconography and machine found in this work is, to say the least, unusual! Today, Raoul Hausmann's best-known work is, no doubt, his scupture-assemblage based on a hairdresser's dummy, known as *The Spirit of Our Times* and *Mechanical Head* (1919-1920, Paris, Musée national d'art moderne). The artist himself once explained how he went about making this piece:

"For some time, I had realized that people actually have no personality at all and that their face is nothing but an image created at the hairdresser's.

"So I decided to start my work with one of the simple, naive heads used by apprentice hairdressers learning how to make wigs.

"What an idea!

"My goal was to reveal the spirit of our times, the spirit of everyone in its most rudimentary state. Intellectuals and poets were saying the most marvelous things about the people. I thought I knew better.

"The average man's only capacities are the ones that chance has stuck him with—you might say the ones that chance has stuck onto his skull; his brain is empty.

"So I got a nice wood head and polished it until it gleamed. Then I started sticking things on it. First, I crowned it with a collapsable cup.

"Next, I attached a purse to the back of its head. I found a little jewel case and put it where the right ear should have been.

"I then put a typography cylinder and pipe stem inside the case.

"Now for the left side.

"Sure enough, I wanted to change materials. I took some kind of a bronze component out of an old camera and attached it to a ruler. As I looked my

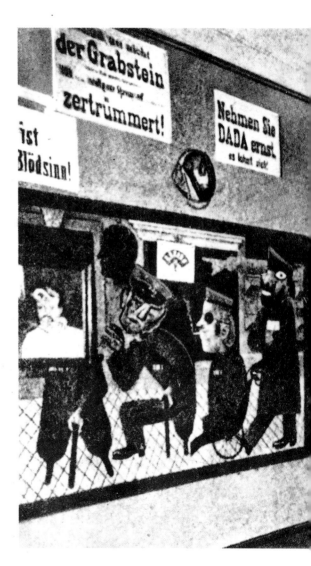

Dada
Fair in Berlin
Burchard Gallery
1920

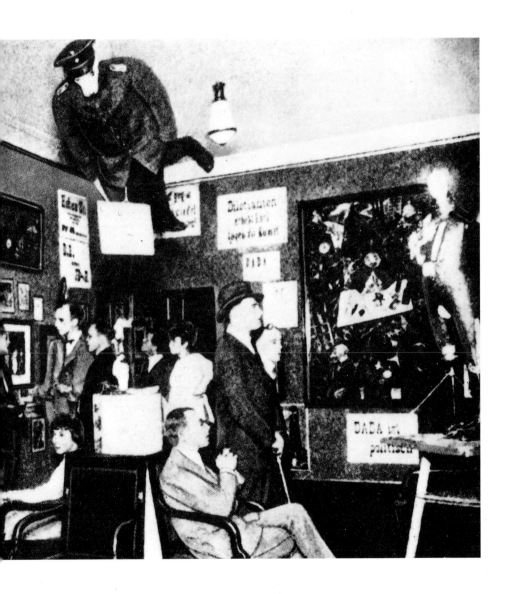

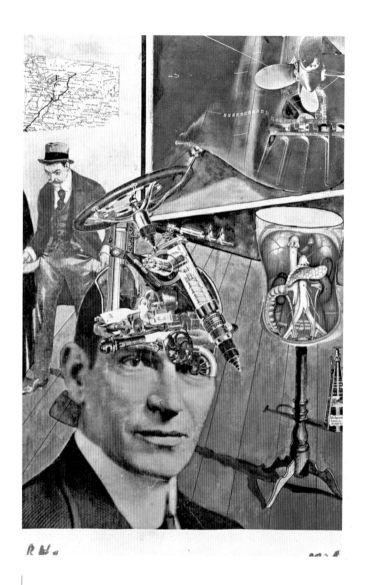

Raoul Hausmann
Tatlin at Home
1920

creation over, I decided it needed an extra touch and added a little piece of white cardboard with the number 22 marked on it, for the spirit of our times was obviously numerical.

"That's how I went about making the head you see today with screws in its temples and part of a tape measure on its forehead (for modern man must do everything with measure).

"Isn't it a love ?"[16]

None of the objects in this *Mechanical Head* was made by the artist himself. All of them actually existed in reality. Hausmann simply selected them and put them together with glue and screws. This work is thus a construction based on the assemblage technique. But the use to which the materials are put also recalls Umberto Boccioni's *Manifesto of Futurist Sculpture*. If Giorgio de Chirico's influence can be detected in this work's iconography and appearance, the characteristic critical dimension of Dadaism and, in fact, of German art in general, is also present. Taken together, these various traits make this sculpture one of the most emblematic works of Dadaism and modern art. The collage *ABCD* (1923, Paris, Musée national d'art moderne) is a later and quite different kind of work; it is made out of all sorts of paper cut-outs (from posters, tracts, bank notes, photographs, illustrations, tickets, etc.) glued onto the support in such a way that a background cannot be distinguished from any central motif. The images, letters, and words create a completely original, flat composition in which what there is to read is as important as what there is to see. Following Picasso, Duchamp, and Arp, Raoul Hausmann used pieces of paper, i.e., ready-made materials, as his only source of form and color. These scraps of paper, which already had a meaning of some kind and existed in the real world before they were introduced into the collage, can be "read" on several levels.

The spirit of Hannah Höch's work closely resembles that of Hausmann's. *Cut with a Kitchen Knife* (Berlin, Nationalgalerie) reveals the sensibility and originality of her vision. It is a large collage of newspaper and magazine cut-outs—including photographs, letters, and words—arranged to fill the entire surface of the support in such a way that no one motif emerges against a background. However, the elements in this "all-over" composition were not chosen at random. Pictures of people are mixed with photographs of big

cities, modern buildings, and machines; and words, letters, and numbers are scattered among them. Hannah Höch's intention here was to create a meaning out of this composition, a meaning that could, for that matter, be termed very close to the Expressionist critique of the city and mechanization.

In his collages, Johannes Baader (1875-1956) chose a very similar option, as shown by one of his rare extant works, *Collage* (1920-1922, Paris, Musée national d'art moderne), a scattering of cut-out letters and words with no apparent motif. An architect by training, who had come to Dada from Expressionism, Baader was surely the Berlin movement's most eccentric personage; indeed, his greatest work was doubtless the provocative and aggressive persona he created for himself. In 1920, he did, however, realize an important construction for the Dada Fair. Entitled *The Great Plasto-Dio-Dada Drama*, the work (no longer extant) was made of scraps of everything imaginable. The artist presented his work as:

"The Great Plasto-Dio-Dada Drama
The Rise and Fall of Germany
By Hagendorf the Schoolteacher
The Incredible Life Story of Super-Dada
A Dadaist Architectural Monument with 6 Floors, 3 Gardens, a Tunnel, and 2 Elevators, with a Top in the Form of a Cylinder.
Description of the Floors:
The ground floor is Predestination before birth and is not a part of History.
Second Floor: The Preparation of Super-Dada
Third Floor: The Metaphysical Ordeal
Fourth Floor: The Initiation
Fifth Floor: The World War
Sixth Floor: World Revolution
Super Floor: the Cylinder screws into the sky and announces the resurrection of Germany by Hagendorf the Schoolteacher and his lectern.
Everlastingly."[17]

The works of George Grosz (1893-1959) are totally different from Baader's. Grosz was as dazzling a draughtsman and merciless a caricaturist as he was a good painter. Fervently anti-Prussian, he had anglicized his first

Left:
Raoul Hausmann
The Spirit of Our Times
1919

Right:
Raoul Hausmann
ABCD
1923-1924

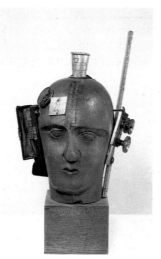

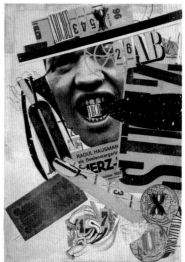

Raoul Hausmann
FMSBW
1918

name and spoke English openly in Berlin during the war, in a spirit of provocation. Even in his early works *The City* (1916-1917, Lugano, Thyssen-Bornemisza Collection) and *Homage to Oskar Panizza* (1916-1918, Stuttgart, Staatsgalerie), both of which are stylistically close to the world of Cubo-futurism and Expressionism, he created masterpieces of thematic interpretation, composition, and detail (brought out by his dazzling technique).

Between 1918 and 1920, he did a number of figurative collages, as well as a series of firmly delineated, grotesque drawings that denounce Weimar society with implacable ferocity. Many of these were published in newspapers or sold in portfolios of engravings.

In *The Guilty Party Remains Unknown* (1918, Art Institute of Chicago), Grosz combined drawing and collage. A bourgeois German, fat and ugly, and a very aggressive-looking prostitute are depicted with the characteristic excess of the artist's mature style, while the still life in the upper right-hand corner is still quite Cubistic in style and the port of Hamburg is represented in a Futuristic manner. Pictures from magazines and cut-out letters and numbers are inserted in the composition. In 1920, Grosz came under Giorgio de Chirico's influence; soon thereafter, he began producing particularly original works, such as *Daum Marries Her Pedantic Automaton George in May 1920, John Heartfield Is Very Glad of It* (1920, Berlin, Galerie Nierendorf), where the traditional techniques of pen-and-ink, India ink and watercolor are closely allied to collage in a sarcastic, allegorical representation of a half-nude woman and a disguised robot in a big city decor. A critical vision of society and the metropolis in the modern world, the work suggests that man is nothing but a machine and woman nothing but a prostitute. Like Raoul Hausmann, George Grosz was attempting to formulate a synthesis of the aesthetics of "metaphysical painting" and Tatlin's "machine art," which he interpreted in terms of the precise neutrality found in industrial drawing. It should be noted here that works realized in 1920 by Rudolf Schlichter, such as the watercolor entitled *The Studio on the Roof* (Berlin, Galerie Nierendorf), and Georg Scholz, such as the painting *Industrial Peasants* (Wuppertal, von der Heydt Museum), also owe a good deal to Giorgio de Chirico and are fairly close to Grosz's work in style, technique, and meaning.

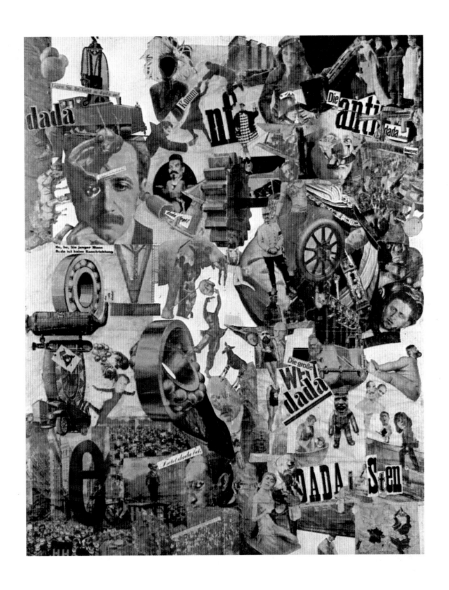

Hannah Höch
Cut With a Kitchen Knife
1919

John Heartfield (1891-1968), who had also anglicized his name,[18] was, even in the practice of his art, the most politically involved of all the Berlin artists; indeed, he remained a member of the Communist Party to his death. Today, he is primarily remembered for his work in the area of photomontage. Using existing photographs or shots he had taken himself, he combined his material on a support to form new images. His first realizations in 1919-1920, such as the collage he published on the cover of *Der Dada*, do not differ significantly from Hausmann's. Working in collaboration with Grosz, he executed such works as *Life and Movement in Universal City at 12:05 Noon* (1919-1920, work missing), a collage that combines pictures of buildings, machines, and public figures with advertisements and texts to evoke the bustle of a big city at noon. His work soon took on much more political connotations, as he began exploring the possibilities of photomontage. For his famous *10 Years After: Fathers and Sons*, realized in 1924, ten years after the outbreak of World War I, three different photographs were used. A procession of skeletons, a marshal, and a parade of children dressed as soldiers were cut out and combined into an astonishing new image. The short caption was added to the resultant composite image, which was then rephotographed and enlarged. Heartfield thus created a new form of expression combining image and text. From this period on, he used his art as a political tool; diverting the original meanings of photographs, he diffused his works as posters and illustrations to ensure that they would reach the largest possible audience.

In addition to these technical and formal investigations, it is also necessary to mention the work of Hans Richter and Viking Eggeling (a Swedish painter) who made the first abstract films using the animation technique: *Rhythm 21* and *Diagonal Symphony* show the successive transformations of geometric figures changing shape. This form of cinematic expression, so different from the cinema of a Chaplin or Griffith, led Arp and Lissitzky to coin the term "filmismus" to refer to these works, which today would be designated as *films d'artiste*.[19]

Finally, this survey would not be complete without mentioning Otto Dix (1891-1969), who lived in Dresden but took part in the 1920 Dada Fair. Dix had been an Expressionist until he discovered Cubo-futurism around 1918;

in 1920, he began doing oil paintings with collage inserts, based on subjects that provoke strong emotional reactions. Indeed, Dix illustrated the most unbearable aspects of everyday life in postwar Germany, depicting the disabled veterans in the streets and the antagonism between them and the rest of the world. *The Match Seller*, painted in 1920, shows a disabled veteran—armless, legless, and blind—sitting on the sidewalk; as a dog urinates on him, he tries to sell his boxes of matches by calling out to the indifferent passers-by. His words, "Streichholz, Streichholz" (match, match), look as if they had been scribbled in chalk directly on the surface of the painting. The matchbox labels and bank notes are collages. In *Disabled Veterans Playing Cards* (Constance, private collection), the vision is all the more atrocious because of the vindictiveness in the invalids' expressions. The violence of the description is further increased by the artist's technique. The cards are authentic, as are the newspapers; moreover, the suit of one of the disfigured veterans is made out of the paper that was used as a cloth substitute during the economic crisis after the Armistice. Along with other works done in 1920, such as *Disabled Veterans* (destroyed by the Nazis) and *Prague Street (Dedicated to my Contemporaries)* (Stuttgart, Städtische Galerie), with their two-dimensional space, schematic forms, acid colors, and carefully finished surfaces, these pictures are unbearable in subject matter and style, but can nevertheless be considered to belong to the tradition of German primitive painting because of their precision and grotesque, moralistic character.

Dadaism began its decline in Berlin after the Dada Fair and had run its course by about 1922-1923, when its principle figures chose new options: some, such as Hans Richter and, for a short time, Hannah Höch, turned to Constructivism, while others, as shown by the evolution of a George Grosz or Otto Dix, took up figurative painting. Only John Heartfield, soon to enlist in the struggle against Fascism, continued his work in the same spirit, faithful to the technique he had introduced to the vocabulary of artistic expression: photomontage.

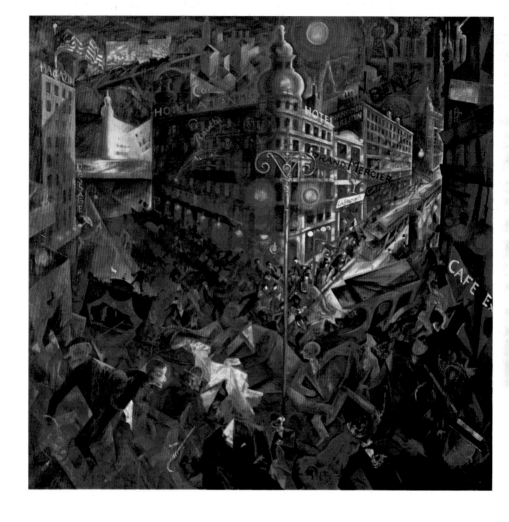

George Grosz
The City
1916-1917

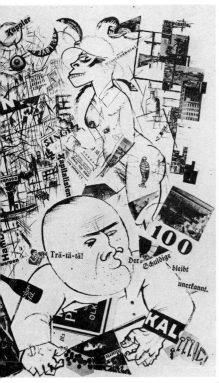

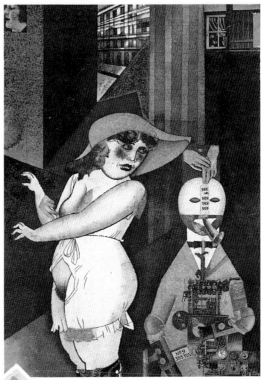

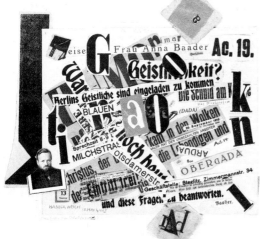

Top left:
George Grosz
The Guilty Party
Remains Unknown
1918

Top right:
George Grosz
Daum Marries...
1920

Bottom:
Johannes Baader
Collage
1920-1922

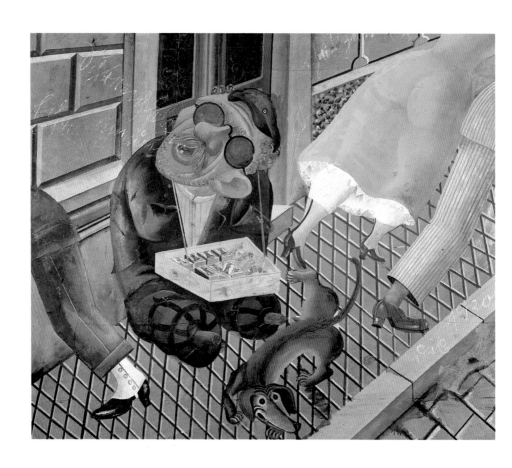

Otto Dix
The Match Seller
1920

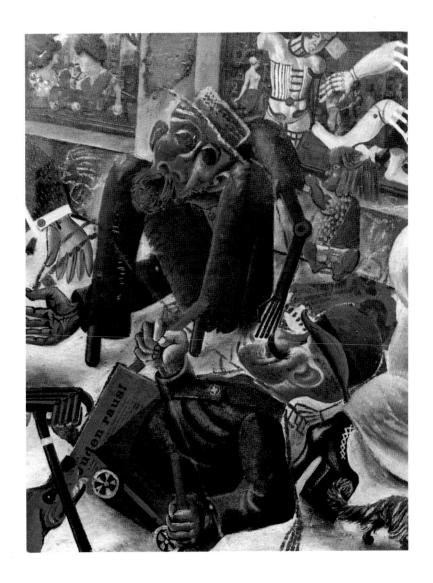

Otto Dix
Prague Street
1920

# DADA IN HANOVER

In Hanover, Dada was the work of a single artist, Kurt Schwitters (1887-1948). The scope of his work, which continued long after and far beyond Dadaism, and his role on the international art scene make him one of the most important figures in 20th-century art. Although Schwitters had numerous ties with the Berlin artists, he remained more or less on the fringes of official Dadaism, his activities being far less politically oriented than those of such artists as Grosz and Heartfield.

In 1919, following a period of Expressionist and Cubo-futurist influence, Schwitters created a new and original kind of art he called "Merz," a meaningless group of letters extracted from the word "Kommerzbank," the middle syllable of which the artist cut out of a piece of printed matter. "Merz" eventually came to designate all of the forms of artistic expression Schwitters utilized. A painter and sculptor, Schwitters was also an editor and typographer; he realized environments, published manifestoes, wrote plays, and composed poems which, from *Anna Blume* to the *Ursonate*, establish his place as one of the major poets of the 20th century. His work was constantly evolving, his production abundant. He was in close contact with Germany's artistic circles (unlike the Berlin Dadaists, he had dealings with Herwarth Walden, published in the review *Der Sturm*, and exhibited his works in the gallery of the same name) and kept abreast of the major international trends (both Theo van Doesburg and El Lissitzky were friends of his). These protean creations and activities allowed him to erect an exemplary artistic career that contrasts completely with the careers of such artists as Grosz, Hausmann, and Baader, whose works, by comparison, strike one as singularly limited or fortuitous.

Schwitters expressed himself primarily in collage, of which he was, after Picasso, the greatest master in the history of art. From 1919 to 1923, his works were often large in size. He was still painting in oil on canvas or a

John Heartfield
Cover of Der Dada, no. 3
1920

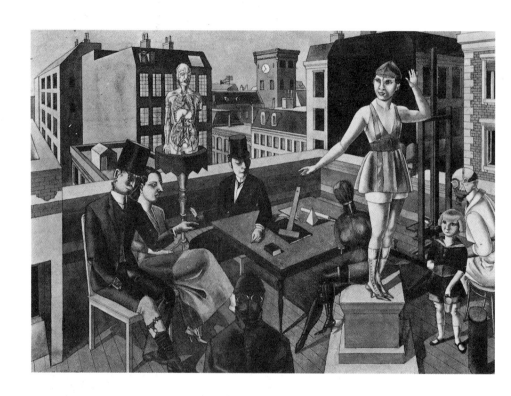

Rudolf Schlichter
The Studio on the Roof
1920

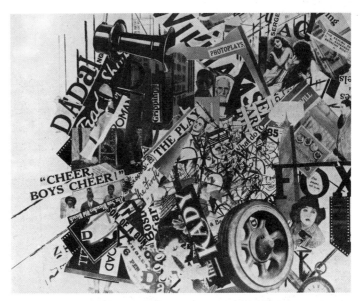

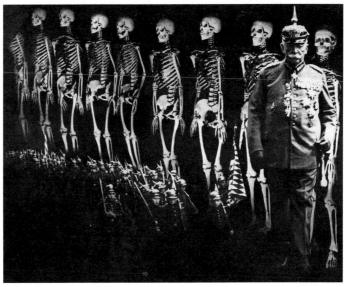

Top:
George Grosz and John Heartfield
Life and Movement (or Dada Fox)
1919-1920

Bottom:
Heartfield
10 Years After: Fathers and Sons
1924

wood support, to which he incorporated all kinds of scrap materials (torn-up paper, undulated cardboard, string, fabric, pieces of wood or old metal, and a variety of objects). At this time, Schwitters would introduce himself by saying, "I'm a painter; I nail my pictures."

Merz art represents nothing: Schwitters' works are always nonfigurative. In *Separated Forces* (1920, Bern, Kunstmuseum), the different materials the work is composed of—including the string stretched across it—act as traditional touches of color. The diagonal composition, use of chiaroscuro, and decomposition of form, however, clearly show the dual influence that Expressionism and Cubo-futurism had exerted on Schwitters. These influences, along with the use of collage, led to the creation of a totally original form of expression. Schwitters, who had used the assemblage technique to elaborate particularly derisory "sculptures" such as *The Holy Affliction* (c. 1920, destroyed)—sculptures which do, however, have a certain poetry about them, in spite of their provocative and humorous character—gradually abandoned oil painting and the use of mixed materials to express himself in collages made entirely of paper cut-outs. Partly due to the origin of the scraps the artist used, these works got smaller and smaller in size; and, as they shrunk, their compositions grew progressively simpler, as in *Mz 394 Pinakothek* (1922, London, Marlborough Gallery). Given the artist's unfailing sense of forms and their utilization, it is not surprising that his creations are extraordinarily varied. In the tradition of collage inaugurated by Picasso—e.g., his *Bottle of Suze* (Paris, Musée national d'art moderne) with its *"un coup de thé,"* a pun on Mallarmé's famous verse—the texts, words, numbers, and letters found in these collages implicate reading to such an extent that some of them can also be considered poems: e.g., *Das Undbildl* (1919, Stuttgart, Staatsgalerie), in which the word "Und" resonates so strongly, and the numerous inscriptions in *Mz 231, Miss Blanche* (1923, Dusseldorf, W. Schmalenbach Collection). Conversely, Schwitters' poetry owes a great deal to his experimentation in the field of painting. His 1922 *Gesetztes Bildgedicht,*[20] a "composed picture-poem" of capital vowels and consonants arranged on an orthogonal grid inside a square, is a visual poem. Cut-outs and collage were even used directly in Schwitters' experiments with poetry. His *Pornographic i-Poem*, published in 1923,[21] was

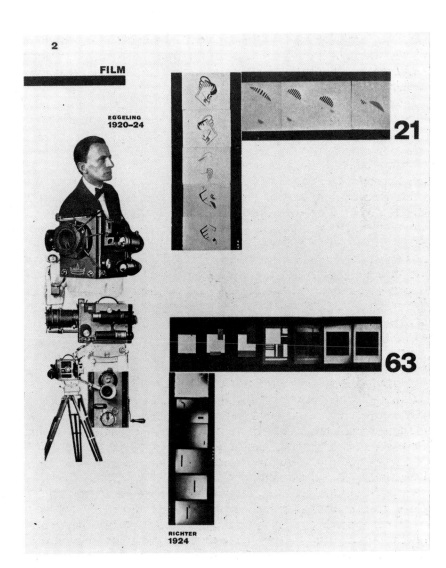

**2**

**FILM**

EGGELING
1920–24

**21**

**63**

RICHTER
1924

Jean Arp and El Lissitzky
Die Kunstismen
1925

obtained by cutting up a nursery rhyme found in a children's book: Schwitters cut the page in half lengthways, keeping only the left side, to which he added a text explaining what he had done. He thus mingled forms and words, painting and poetry, letters and typography in an effort to create a total work of art.

Schwitters often exchanged ideas with Theo van Doesburg, who also wrote concrete poetry and even turned up in Dadaist circles using the pseudonym I. K. Bonset. Influenced by Neo-plasticism, the Hanover artist began to evolve in a new direction in 1923. Without giving up his mode of expression, he adopted simpler forms, purer (and fewer) colors, and very clear compositions, often based on horizontals and verticals (*Merz 600 Leiden*, Hamburg, Kunsthalle). Continuing to use the assemblage technique, he salvaged boards and scraps of wood that he then partially painted and arranged in geometric patterns; the result was works based on subtly balanced dissymmetries and a particularly refined range of colors (*Merzbild Kijkduin*, 1923, Lugano, Thyssen-Bornemisza Collection). In 1923, as Dadaism was dying out in Berlin and already on the decline in Paris, Schwitters launched the review *Merz* which, though Dadaist in inspiration, quickly became an important mouthpiece for the entire international avant-garde.

Schwitters expressed himself using collage, typography, poetry, and the "happening"; in fact, he saw everything he did—his daily behavior, his least little action—as a part of his art. One of his most original projects consisted in constructing an enormous sculpture in his own house; started in 1920 and constantly enlarged and transformed over the years, the sculpture finally overflowed, forcing Schwitters to cut a hole in the ceiling in order to continue his work on the second floor. Known as the *Merzbau* or "K de E," an abbreviation for "Kathedrale des erotischen Elends" (Cathedral of Erotic Woes), this delirious, obstinate construction, a veritable parasite invading the artist's living quarters and destroying everything that got in its way, testifies to the absolute primacy Schwitters accorded artistic creation. By its very nature, the work could not be moved or sold; it was a sculpture, a piece of architecture, a painting, and a set of inscriptions combined, i.e., what is today called an environment: a constantly evolving blend of forms, rhythms, and surprises.

Schwitters did not invent collage as a medium, but he did give it a new moral value. By using it as he did, he radically renewed visual expression. When he rejected traditional painting as an expression of the old order, he turned to small supports onto which he glued scrap materials, the rubbish of 20th-century society. These collages were made rapidly. Calling for limited technical skill, they remove the artist from his pedestal and testify to an ecological interest in the re-use of materials. Incorporating any and all materials—bar none—to what he presented as art, Schwitters gave them an artistic status. Art was meant to reveal the object, which, shown as found or in some way recycled, took on a new dimension and sometimes acquired a new function. For Schwitters (as for Léger and Mondrian in a different way), art had to be in harmony with the world. Using scraps and rubbish to construct his art, Schwitters left a record of a state of civilization; but, not as politically involved as the Berlin Dadaists, he always ensured the primacy of the "artistic" message. Although Schwitters, like the Dadaists and Marcel Duchamp, mocked art—but with different means and, doubtless, different ends—he did, nevertheless, retain a very high idea of it. His goal was not to eliminate art, but to transform it. Schwitters made art out of absolutely anything and everything, and never favored one material or form of expression as nobler than others. In 1932, he declared: "With determination, one can destroy a world and, with knowledge and a respect for possibilities, construct a new world out of the ruins."[22]

The *Merzbau* was part of this revaluation. A passage from collage—by definition, a mural work of limited size—to three-dimensional space, it was a fundamental reflection on the role of art and its decorative and social functions. As in his collage-poems, use of typography, and public poetry readings—which were always an event—Schwitters wanted to create a total work of art. What he called "Merzgesamtkunstwerk" finally merged with his own existence. Like Marcel Duchamp, he contributed to changing the artist's role and status, since he too saw himself, as artist, as the matter of his art. In his *Isms of Art*, Schwitters declared: "*Alles was ein Künstler spuckt ist Kunst.*" Anything and everything an artist spits out is art. The uncontested master of the second generation of nonfigurative art, Schwitters, the great forerunner, has profoundly influenced contemporary artistic creation.

# DADA IN COLOGNE

The last important center of Dadaist activity in Germany was Cologne between 1918 and 1922. Like the Berliners, Max Ernst and Theodor Baargeld (the latter highly influenced by Picabia), joined by Jean Arp in 1919, made themselves known in the city by stirring up controversies, publishing reviews (*Der Ventilator, Die Schammade*), and organizing one particular exhibition that was quickly closed by the occupation authorities. Working together, Arp and Ernst did collages they called "Fatagaga," an abbreviation for "fabrication de tableaux garantis gazométriques" (manufacture of pictures guaranteed to be gasometric); an example is *Physiomythologisches diluvialbild* (1920, Hanover, Brusberg Gallery), realized using the photomontage technique. During this period, Ernst, also very influenced by Giorgio de Chirico, produced several of his best works by combining different techniques of collage. In *1 Kupferblech 1 Zinkblech 1 Gummituch 2 Tastzirkel...* (circa 1920, work missing), the artist pieced together fantastic figures using pictures of various objects (goggles, a retort, pipes...) he had cut out of printed matter, then completed his composition with traditional watercolor and drawing. *The Little Lacrimal Fistula that Says Tick Tock* (1920, New York, The Museum of Modern Art) is made of braided strips of wallpaper transfigured into a monumental wall. In Max Ernst's works, the title cannot be dissociated from the image (it is, moreover, as in Paul Klee and Kurt Schwitters, usually inscribed on the work itself). It confers a mysterious, poetic meaning on the composition, which is always, if not figurative, at least allusive. Ernst's works testify to a great variety of inspirations (e.g., *Dada Degas by Dada Max Ernst the Knitter*, Paris, formerly in the collection of Louis Aragon). By systematically bringing together elements taken out of their original context, Ernst was able to create new visions of reality, based—often humorously—on incongruity, paradox, and the uncanny. In 1921, he began experimenting with a new kind of collage using, as a point of

departure, 19th-century illustrations, mostly woodcuts, taken from such publications as *Le Magasin pittoresque* and *L'Illustration*. The artist would cut out certain parts of these illustrations and insert them into new compositions so carefully that it is quite difficult to detect the montage. The resultant images are perfectly homogeneous, as in *The Preparation of Bone Glue* (1921, Paris, formerly in the Galerie François Petit). During his Surrealist period, Ernst further developed this technique in his famous books of plates *La Femme 100 Têtes* (1929) and *Une semaine de bonté* (1934).[23]

A group of artists including Anton Räderscheidt, Franz-Wilhelm Seiwert, and Angelika Hoerle formed in Cologne at this time. But Arp went to Paris in 1920, and Ernst followed in 1922.

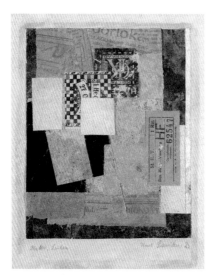

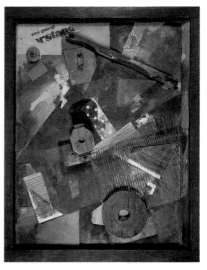

Top left:
Kurt Schwitters
Merz 600 Leiden
1923

Top right:
Kurt Schwitters
Separated Forces
1920

Bottom:
Kurt Schwitters
Mz 231 Miss Blanche
1923

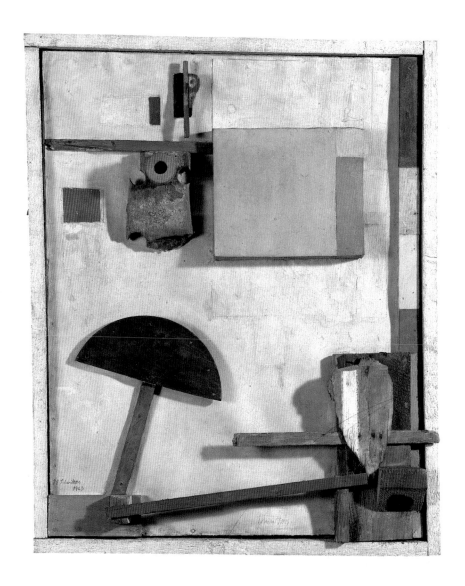

Kurt Schwitters
Merzbild Kijkduin
1923

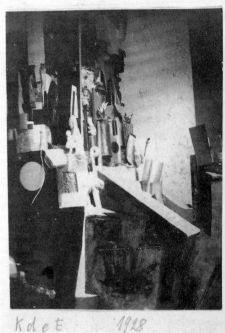

**pppppppp**

**p**ornographisches **i**-Gedicht

Die Zie |
Diese Meck ist |
Lieb und friedlich |
Und sie wird sich |
Mit den Hörnern |

Der Strich zeigt, wo ich das harmlose Gedichtchen aus einem Kinderbilderbuch durchgeschnitten habe, der Länge nach. Aus der Ziege ist so die Zie geworden.

Und sie wird sich | nicht erboßen,
Mit den Hörnern | Euch zu stoßen.

Left:
Kurt Schwitters
The Holy Affliction, 1920
pppp... Pornographische i-Gedicht, 1923

Right:
Kurt Schwitters
Merzbau, 1928
Gesetztes Bildgedicht, 192.

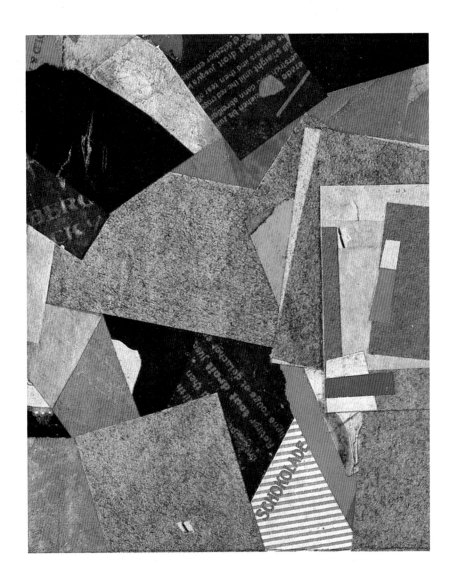

Kurt Schwitters
Mz 394 Pinakothek
1922

# DADA IN PARIS

As in Zurich, New York, and Berlin, Dadaism had a certain number of forerunners in Paris; but, with the exception of Marcel Duchamp, these pre-Dadaists tended to be poets, writers, and editors rather than visual artists. In 1912, Arthur Cravan began publishing the review *Maintenant*, which continued until 1915. In 1916, Pierre-Albert Birot, himself a painter and sculptor, launched *SIC*, and that review took on considerable importance in wartime Paris. In 1917, Pierre Reverdy, in turn, created *Nord-Sud*, which directly foreshadowed what Parisian Dadaism would become: on the whole, a more literary movement than was found in the other cities where Dadaism flourished. In 1919, Francis Picabia moved from Barcelona to France, and brought his review *391* with him. The first issues, published in New York and Spain, had notably included insolent cover illustrations consisting, for example, of photographs of a ship propeller and electric light bulb captioned, respectively, "ass" and "American woman." Picabia's love of provocation and nonsense found expression in his literary pamphlets as well as in such visual works as the painting *Straw Hat* (1921-1922, Paris, Musée national d'art moderne) with its casual declaration: "*M... pour celui qui le regarde.*" The work was refused at the Salon des Indépendants. From the same period, Picabia's *Dance of Saint Guy* (Paris, Picabia estate) consists of nothing but strings stretched across an empty frame and little pieces of cardboard bearing scandalously ridiculous messages like "Dance of Saint Guy" and "Tobacco Rat." In much the same vein, the artist published an ink spot in *391* and captioned it "The Blessed Virgin"; on another occasion, he presented a bill as a drawing supposedly illustrating a text by Tzara.[24]

*The Cacodylic Eye*[25] (1921, Paris, Musée national d'art moderne), which hung for many years in the Parisian cabaret "Le boeuf sur le toit," carries the parody of art to the limit. The work consists of nothing but a painted eye,

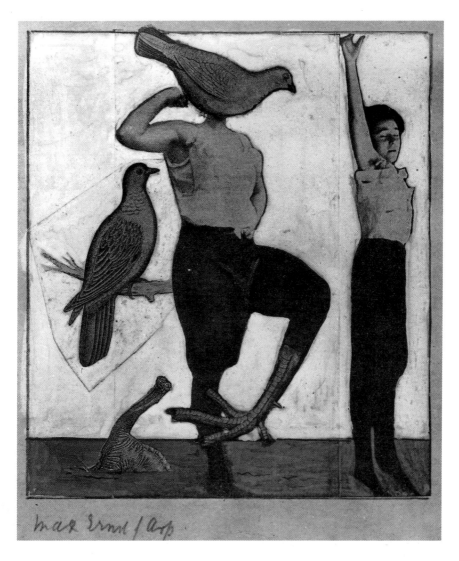

Jean Arp and Max Ernst
Physiomythologisches diluvialbild
(Fatagaga)
1920

similar to those seen on billboards, surrounded by the signatures of artists, writers, and musicians who had signed the canvas when they visited Picabia's studio or at a party organized by a lady friend of the artist's. Several quite well-known works of Picabia's, such as *The Match Lady* (Paris, private collection) and *Feathers* (Milan, private collection), made out of various unusual materials (feathers, macaroni, buttons, pins, straw, matches, coins...) glued onto the surface of canvases painted in oil, though they are Dadaist in inspiration (if less radically so than the works discussed above), would seem to be later works and can probably be dated 1924-1925.

In 1919, Marcel Duchamp came back to Paris. In 1921, he was followed by Man Ray, who became one of the most celebrated photographers of his day (his portraits—of Tzara, for example—are admirable) and also made various paradoxical-looking objects: an iron, for example, the bottom of which is spiked with a row of nails (*Gift*), or a metronome with the photograph of an eye paperclipped to its pendulum (*Indestructible Object*, 1923). If such works are successful, largely due to the surprise they provoke, Man Ray's paintings, on the other hand, are rarely very satisfying.

As for Marcel Duchamp, he realized what he called "assisted" or "corrected" ready-mades. In 1919, he took his pencil and drew a mustache on a reproduction of the Mona Lisa, and labeled the result "L.H.O.O.Q." (which, when read aloud, gives *"Elle a chaud au cul"*: "She's got hot pants"). Using an image that has been reproduced so often that it has become trite and, at the same time, mocking the most famous work in the history of painting, Duchamp created one of his most disrespectful works. In 1921, the artist placed sugar cubes (made of marble) in a bird cage out of which a thermometer and cuttlebone are sticking. The title, *Why not Sneeze Rrose Sélavy ?* (Philadelphia Museum of Modern Art),[26] is completely unrelated to the object, which is itself completely meaningless.

In 1920, with Man Ray's help, Marcel Duchamp created a new kind of sculpture: *Rotary Glass Plates* (New Haven, Yale University Art Gallery) is a real machine that could, in a sense, be said to materialize the 1914 *Chocolate Grinder*. But, complicated as it looks, this machine can do nothing but produce the optical illusion of a spiral. An anti-painting turned into reality, this machine is utterly useless. It can produce nothing but art.

Along with László Moholy-Nagy's *Licht Raum Modulator*, this art machine anticipates the kinetic art of the fifties and sixties.

In 1923, Duchamp stopped work on his most successful or, at least, because of its size, technique, and abstruseness, his most famous work: *The Large Glass*, also entitled *The Bride Stripped Bare by her Bachelors, Even* (1915-1923, Philadelphia Museum of Art). Realized on sheets of glass with paint and lead foil, this work re-presents different elements—some recognizable, others not—that Duchamp had already used in previous works, e.g., the *Chocolate Grinder*. These elements are brought together to form a complex mechanism shown in perspective and in space (the transparent support being installed like a window between image and viewer). The technique is surprising because of the use of glass and steel; but even more surprising is the representation itself, which intrigues the viewer precisely because of its near triviality. Few 20th-century artworks have given rise to as much commentary and exegesis; and it must be recognized that the artist encouraged this situation with his silence and the sibylline character of the "notes" he left. In point of fact, as Jean Clair has shown,[27] the work is only an experiment with perspective and pluridimensional geometry. But largely because of the strange title that Duchamp, a master of language and humor, gave this work, it has always been perceived as a great enigma.

In 1923, when he proclaimed his *Large Glass* "finished," Duchamp had already practically given up all artistic activity. Afterwards, he produced very few works, devoting most of his time to living, playing chess, and elevating his existence into a myth. Ineluctably, the logic of his anti-art stances had led him to give up art.

Parisian Dadaism was not, in fact, greatly influenced by the overly demanding and intellectual Duchamp. It was writers who soon came to the fore and dominated the Paris scene in their own specific way. In 1919, André Breton, Philippe Soupault, and Paul Éluard founded the review *Littérature*, the name of which clearly indicates what its orientation was. The single issue of Tristan Tzara's review *Le Coeur à barbe*, published in April 1922, was also exclusively literary (although it did include a superb typographical cover designed by Tzara himself). Theatre and performances also played an important role in Parisian Dada. The 1920 Dada Festival, held at

Max Ernst
Dada-Degas
1920-1921

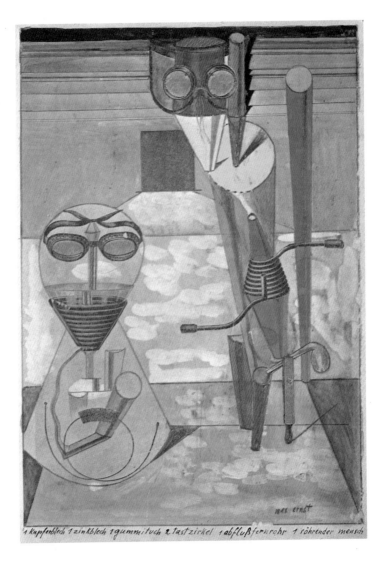

1 Kupferblech 1 zinkblech 1gummituch 2 Tastzirkel 1 abflußfernrohr 1 röhrender mensch

Max Ernst
1 Kupferblech, 1 Zinkblech
1 Gummituch, 2 Tastzirkel,
c. 1920

the Salle Gaveau, was a somewhat provocative theatrical event. And one of the most important moments in Paris Dada came in 1923 when Tzara's play *Le coeur à gaz* was performed at the Théâtre Michel with costumes by Sonia Delaunay. But perhaps the real highpoint in Dada theatre came considerably earlier when, in 1920, Picabia's "Festival manifeste presbyte" was put on at the Théâtre de l'Œuvre and André Breton appeared as a sandwich man decorated with a target and an impertinent text.

Besides several other "provocations" of this sort, quite innocuous compared to those organized in Berlin and by Schwitters, the Paris Dadaists organized several exhibitions of works by Picabia, Man Ray, and Max Ernst. The invitation to an Ernst exhibition in 1921 bore the following message: "You are nothing but children/ Dada Exhibition/ Max Ernst/ mechanoplastic plastoplastic drawings anatomic antizymic aerographic antiphonary waterable and republican painting-paintings/ No admission charge/ Keep your hands in your pockets/ Easy exit/ a picture under your arm/ Beyond painting / the ladies are requested to bring all of their jewels."[28] In Paris, Max Ernst continued the work he had begun in Cologne: *Two Children Are Threatened by a Nightingale* (1924, New York, Museum of Modern Art), painted at the end of the Dadaist period, clearly shows, in the representation of the fictional landscape and incongruous positions of the human figures, how much this artist could owe to Giorgio de Chirico, as well as to the collage technique, while also respecting—with considerable elegance—the traditional definition of a picture.

Other artists might also be mentioned: the painter Jean Crotti, for example, who had wed Duchamp's sister Suzanne, herself a painter too; or Serge Charchoune, a Russian emigrant who had come to Paris from Berlin. But in the final analysis, Dadaist activity in Paris never attained the intensity it had in Germany and died out fairly quickly. Ironically, one of the highest Dada achievements in Paris took place after the movement's demise when, in 1924, Francis Picabia and Erik Satie's ballet *Relâche* was performed by Rolf de Maré's Ballets Suédois with a phenomenal set designed by Picabia.

Dada was truly international: other centers were more or less active for varying periods of time in Italy (Giulio Evola), Czechoslovakia (Jaromir

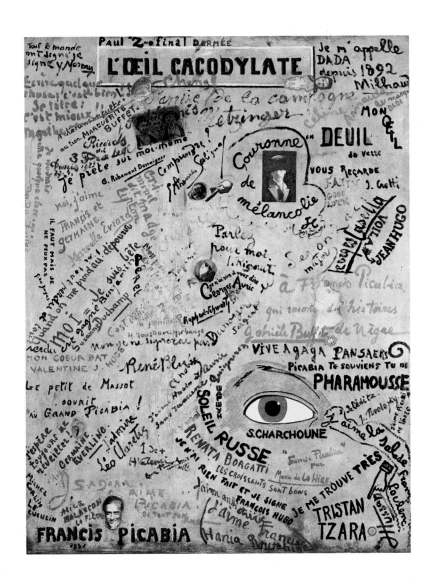

Francis Picabia
The Cacodylic Eye
1921

Krejcar), the U.S.S.R. (Iliaszd), Hungary (Lajos Kassak and László Moholy-Nagy), Belgium (Paul Joostens, Michel Seuphor, and Clément Pansaers), and the Netherlands (Theo van Doesburg, who used the pseudonym I. K. Bonset to publish the review *Mecano*, the four issues of which were distributed with *De Stijl*). The movement's internationalism is indeed striking, as is the extent to which it was paralleled by the development of Constructive art. In 1922, the first and last international Dada convention, held in Weimar, the capital of Thuringia and (until April 1925) of Bauhaus, was at once the apotheosis and swan song of Dadaism. Arp, Tzara, van Doesburg and his wife Nelly, Richter, Moholy-Nagy, and Schwitters were present. But by this time, at least for these artists, Dadaism was inseparable from Constructivism.

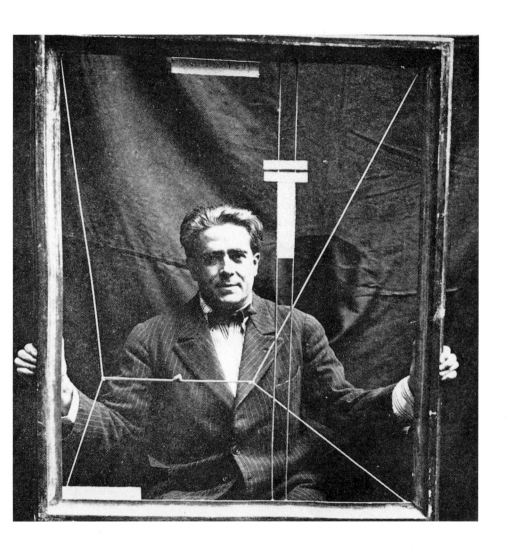

Francis Picabia
Dance of Saint Guy
1919-1920

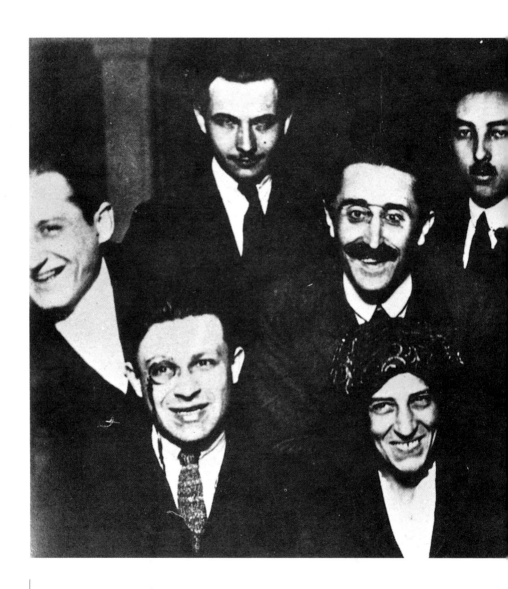

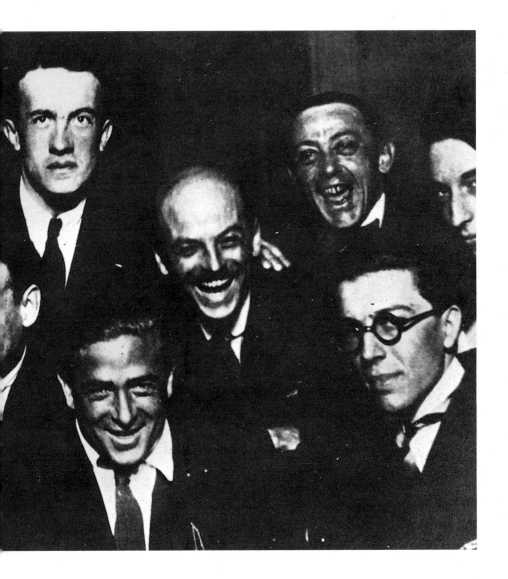

Contributors to the review 391 in 1921
Firts row: Tzara, Céline Arnaud, Picabia, Breton
Second row: Peret, Dermée, Soupault, Ribemont-Dessaignes
Third row: Aragon, Fraenkel, Eluard, Pansaers, Fay

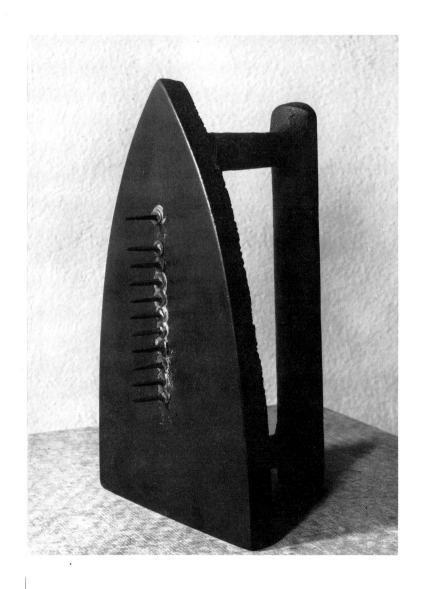

Man Ray
Gift
1921

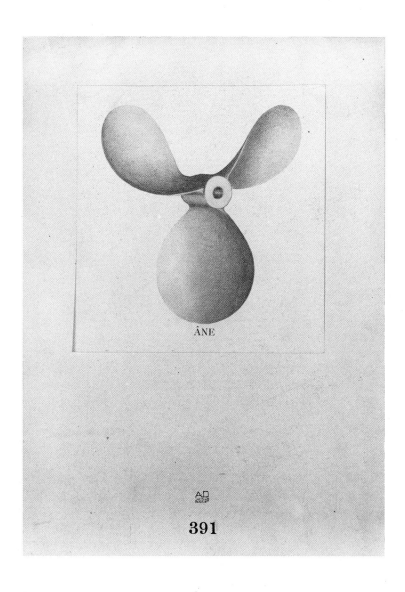

ÂNE

391

Francis Picabia
Cover of the review 391
June 1917

# THE MEANING AND POSTERITY OF  ISM

Dada turned out to be a very short-lived movement. And, unlike Constructivist painting, it cannot be said to have been particularly original, nor can it be credited with any real coherence or specificity, on the visual level. Indeed, there would seem to be no relationship whatever between, for example, Marcel Duchamp and Raoul Hausmann. Taken together, the works of the Dadaists form a veritable mosaic of styles: nonfigurative in Arp, Taeuber, Janco, and Schwitters, Cubo-futurist in the early works of Grosz and Dix, Expressionist (and influenced by Kandinsky) in Richter and Hausmann, Expressionist (and influenced by the Brücke) in Schad and Baader, "metaphysical" in Grosz, Ernst, Hausmann and, quite often, Heartfield, and figurative in Schlichter and Dix. To this list, two names must be added: Duchamp and Picabia, utterly unclassifiable.

When Dadaism faded out around 1922, most of these artists that the war and certain shared concerns had brought together either continued in the direction they had been exploring—such was the case for Arp, Heartfield, Picabia, and Duchamp—or evolved in new directions: Schwitters, Moholy-Nagy, and Hans Richter turned to Constructivism; Schad, Dix, Grosz, and Schlichter chose figurative painting; and, Ernst and Höch enlisted in the new Surrealist movement. Others, however, such as Baader and Hausmann, practically stopped working altogether. Beyond ideology and political involvement, the truly important thing about Dada is to be found in the primacy the movement accorded the exploration of new techniques and means of expression such as collage, typography, photography, and cinema. It is no exaggeration to say that Hausmann, Heartfield, and Schwitters defined the use and value of collage in a way that radically distinguishes their works from those created by Picasso and the Futurists. Moreover, the different uses the Dadaists made of collage influenced the Constructivists in their own investigations (e.g., the photomontages realized

Philippe Soupault
Cité du Retiro
1921

by Max Burchartz, César Domela, and Anton Stankowski). In the works of Tzara, Heartfield, and Schwitters, typography and printing were radically renewed, as was photography with the invention of the photogram by Christian Schad and Man Ray.[29] The Dadaists also made a major contribution to cinema: Richter and Eggeling invented nonfigurative cinema, while Man Ray and Picabia investigated the use of filmed images in a radically new way (e.g., in *Entr'acte*, directed with René Clair).[30]

Although space has not allowed us to go into great detail about the Dadaists' literary activities, it should be noted that, if Ball and Tzara devoted themselves exclusively to writing, Hausmann, Arp, Schwitters and, to a lesser extent, van Doesburg and Picabia were very nearly as much poets as they were painters. With their poetry readings, performances, manifestoes, and acts of provocation or humor, as well as their continual efforts to blend together the different modes of human expression, the Dadaists perfected what the Futurists had begun and, so doing, invented what is today called the happening; similarly, one of the most dazzling demonstrations imaginable of the transition from painting to the third dimension, the *Merzbau* can truly be called the first "environment."

In the purely pictorial realm, the contribution of the Dadaists cannot be underestimated. Indeed, several of the 20th century's greatest artists belonged to the movement: Arp, Taeuber, Schwitters, and Duchamp, as well as Picabia, Ernst, Grosz, Dix... Formally very rich, these artists' collages, paintings, and reliefs figure among the masterpieces of 20th-century art, which is indeed paradoxical when we recall that their avowed goal was to make "anti-art." At the 1920 Dada Fair in Berlin, Grosz and Heartfield had, however, had themselves photographed next to a poster that proclaimed: "Art is dead! Long live Tatlin's new machine art!" In other words, the Dadaists also recognized the urgency of creating something new once the old values had been destroyed.

Most of these artists shared an attitude of revolt. Tzara declared: "We are not looking for anything!" and "A priori, i.e., our eyes shut, Dada places Doubt before action and above everything else. Dada doubts everything. Dada is an armadillo. Everything is Dada. Beware of Dada!"[31] Similarly, the French poet Georges Ribemont-Dessaignes wrote: "What's beautiful ?

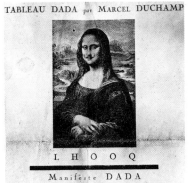

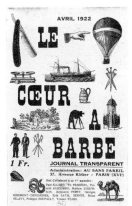

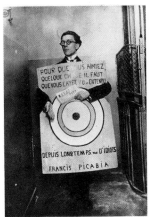

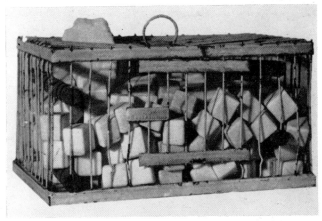

Marcel Duchamp
Rotary Glass Plates, 1920

André Breton
at the Théâtre de l'Œuvre

Marcel Duchamp
L.H.O.O.Q. 1919

Marcel Duchamp
Why not Sneeze Rrose Sélavy ? 1921

Le cœur à barbe
1922

What's ugly ? What's great, or strong, or weak ? Who are Charpentier, Renan, and Foch ? No idea. Who am I ? No idea, no idea, no idea."[32] The Dadaists wanted to get rid of all of the West's political, social, cultural, and artistic traditions, which they held responsible for the carnage of World War I. They rejected everything: they were against the past, but also against the future. Dada ridiculed all human activities and feelings: the machine (Picabia), society (Grosz), art (Schwitters)... And Tzara declared: "Art needs major surgery." The Dadaists made use of the chaos that could be seen in Cubism, Futurism, and Expressionism to denounce what they saw as the chaos of their age. The collapse of traditional perspective and harshness of the techniques found in the Dadaists' paintings, the dislocations of language in their poems, and the wild uproars created in and by their performances may be seen as expressions of the apocalyptic visions of Höch, Hausmann, Schwitters, Grosz, and Dix. Opposed to science and the idea of progress, Dada exalted the absurd and the idea of liberty.

Dadaism placed pessimism and gaiety, destructive nihilism and humor side by side. Despite the movement's brevity and the eclecticism of its productions, it must be seen as an essential episode in the history of 20th-century art. It fueled creativity in the arts and cleared the way for the birth of Surrealism in France. Since 1945, the spirit of Dada has often been seen in American artists such as Robert Rauschenberg, John Cage, and Alan Kaprow, and has resurfaced in Europe in the works of Arman, Tinguely, and the Fluxus movement. More than half a century after the movement's demise, the spirit of Dada lives on.

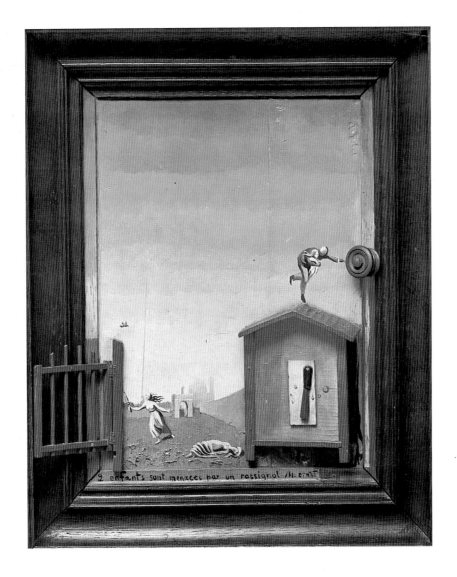

Max Ernst
Two Children Are Threatened by a Nightingale
1924

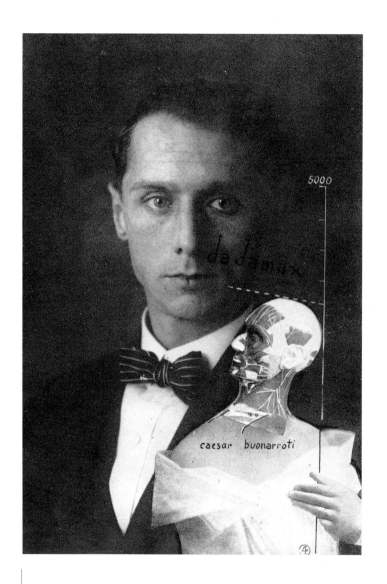

Max Ernst
The Immortality of Buonarroti
1920

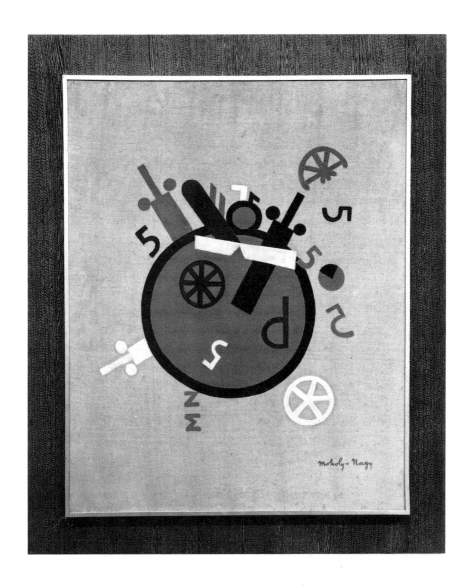

László Moholy-Nagy
Die Grosse Gefühlsmachine
1920

# ANTHOLOGIE
# DADA

ARP

**Parait sous la direction de TRISTAN TZARA**
**MOUVEMENT DADA**
**Zurich Seehof Schifflande 28**
**Prix: 4 Frs**

Tristan Tzara

Christian Schad
Transmission
1919

Hannah Höch
New York
c. 1922

Duchamp
Dust Farm
Photograph by Man Ray
1920

Francis Picabia

Tristan Tzara and René Crevel
Photograph by Man Ray

Cacodylic New Year's Eve
Celebration
1921

*nal - Reveillon - Cacodylate | 1921*

L. Bailli          R. Radiguet

Baronne          Marthe     Germaine     P. Spigario
Double           Chenal     Everling

Francis Picabia
Relâche
1924

Tristan Tzara

# FOOTNOTES

1. New York, 1968.

2. A group of artists calling themselves the "Incohérents" appeared in Paris during the last decades of the 19th century. Founded by the writer Jules Lévy in 1882, the group brought together painters, illustrators, writers, and musicians. In 1882, they held their first exhibition at a Parisian cabaret called the Chat Noir; they continued exhibiting on an annual basis up to 1887 and held their last exhibition in 1889. The group included Charles Angrand, Caran d'Ache, Jules Chéret, and Adolphe-Léon Willette, as well as Alphonse Allais, Mac-Nab, and pseudonymous members such as Mac Arony, Paul Hichinelle, Totor and... Dada! "Incoherent art" was, for the most part, based on visual puns—e.g., a picture illustrating the pun "*Porc trait par Van Dyck*" (based on the homophony in French of "portrait by" and "pig drawn by")—which the group used to ridicule all forms of artistic expression as well as the institutions of their day. Some of the artists who belonged to this group must have been known to the Zurich Dadaists, since the program for an event held at the Galerie Dada on May 2, 1917, indicates that the entertainment included "Alphonse Allais, 'Le petit veau'" and "Mac-Nab, 'Le fiacre.'" For more information about this group, the existence of which Pierre Soulages so kindly brought to my attention, the following studies can be consulted: Philippe Robert-Jones, "Les Incohérents et leurs expositions," *La Gazette des Beaux-Arts*, Paris, October 1958; Daniel Grojnowski, "Une avant-garde sans avancée: les Arts incohérents 1882-1889"; and Denys Riout, "Remarques sur les Arts incohérents et les avant-gardes," *Actes de la recherche en sciences sociales*, no. 40, Paris, November 1981, pp. 73-88.

3. See the *Marcel Duchamp* exhibition catalogue, Musée national d'art moderne, Centre Georges-Pompidou, Paris, 1977, 4 t.

4. The earliest known example of the word "Dada" in print would seem to be that found in the journal *Cabaret Voltaire*, published in 1916.

5. Quoted by Hans Richter in *Dada Art and Anti-Art*, New York, 1966, 1978.

6. *Ibid.*, pp. 38-39.

7. In the *Arp* exhibition catalogue, Musée national d'art moderne, Paris, 1962, p. 38.

8. *Ibid.*, p. 82.

9. *Der Sturm* (The Storm) is the name of the review that the musician, poet, and art critic Herwarth Walden (1878-1941) founded in Berlin in 1910; the review began as the mouthpiece of the Expressionist movement and soon took up the cause of the entire artistic avant-garde. Walden's Berlin gallery, also called Der Sturm, exhibited the works of the avant-garde.

10. Futurist typography (as seen, e.g., in F. T. Marinetti's experimentation with "words at liberty") was of considerable importance.

11. Quoted by Hans Richter, *op. cit.*

12. Letter to Richard Hülsenbeck, dated November 28, 1916, quoted in Hans Richter, *op. cit.*

13. For a description of the Société Anonyme's collection of Dadaist and Constructivist works, see the book by Robert L. Herbert, Eleonor S. Apter, and Elise K. Kenney, *The Société Anonyme and the Dreier Bequest at Yale University*, New Haven and London, 1984.

14. See, for example, Raoul Hausmann's manifestoes *Synthetisches Cino der Malerei* and *Material der Malerei, Plastik und Architektur.*

15. Constantin Umansky's *Neue Kunst in Russland*, Munich and Potsdam, 1920, was the first book on Russian art to be published in the West since the Bolshevik Revolution. The author mentioned the names of Malevich and Tatlin, crediting the latter with the invention of a new form of expression called "machine art," but did not illustrate his remarks with reproductions of their works: hence the Berlin Dadaists' very loose interpretation of that concept.

16. Raoul Hausmann, in the *Raoul Hausmann* exhibition catalogue, Moderna Museet, Stockholm, 1967.

17. Quoted by Raoul Hausmann in *Courrier Dada*, n.d. (1958), pp. 79-80.

18. John Heartfield's real name was Helmut Herzfeld. His brother was the publisher Wieland Herzfelde (Malik Press).

19. Hans Arp and El Lissitzky, *Die Kunstismen*, Zurich, 1925, p. 2.

20. Reproduced in Friedhelm Lach, *Kurt Schwitters: Das literarische Werke,* t. 1, Lyrik, Cologne, 1973, p. 200.

21. *Ibid.*, p. 95. Published in the second issue of the review *Merz*, the *Pornograpic i-Poem* ("i" designating an art form of Schwitters' invention that is more or less equivalent to "Merz") might be translated as follows:
"The go
This kid is
Kind and quiet
And she goes
With horns
The line shows where I cut the little poem from a children's book lengthways.
That's how the goat became a go.
And pretty soon she is going
To ram you with her horns."

22. Kurt Schwitters in *Abstraction-création art non figuratif 1932*, Paris, 1932, p. 33.

23. Like John Heartfield's photomontages, which were made to be photographed and then reproduced as often as desired (there are no "originals"), Max Ernst's collages of cut-up engravings (the artist long refused to divulge what engravings he was using and how he went about turning them into collages) were also made to be reproduced.

24. Tristan Tzara, *Seven Dada Manifestoes,* New York, 1979.

25. The title of this work comes from the use of cacodyl to treat the kind of eye inflammation Picabia was suffering from at this time.

26. Rrose Sélavy was the pseudonym of Marcel Duchamp in drag.

27. See Jean Clair, *Marcel Duchamp ou le grand fictif*, Paris, 1975, and the catalogue of the exhibition at the Centre Georges-Pompidou, *op. cit.*, 1977.

28. The exhibition was held at the Au Sans Pareil gallery.

29. A photograph produced without a camera, obtained using only photographic paper, objects placed on it, and light, the photogram was invented by Man Ray (who used the term rayogram) and Christian Schad (who spoke of Schadography); soon afterwards, the same procedure was very successfully used by László Moholy-Nagy.

30. This short film, *Entr'acte* (Intermission), was directed by René Clair and Francis Picabia to be shown during intermission at the ballet *Relâche*.

31. Tristan Tzara, *op. cit.*

32. Georges Ribemont-Dessaignes, *Dada*, no. 7, March 1920, p. 2.

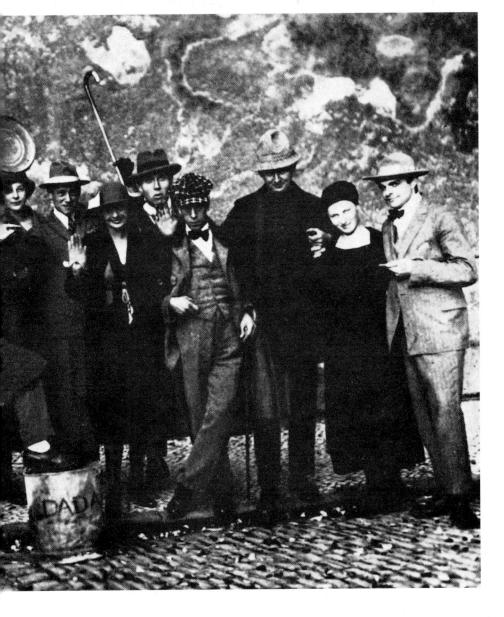

Constructivism-Dada Congress in Weimar, 1922
Left to Right: Kurt Schwitters, Jean Arp, Max Burchartz,
Frau Burchartz, Hans Richter, Nelly van Doesburg, Cornelis van Eesteren,
Theo van Doesburg, Peter Rohl, Frau Rohl, Werner Graeff

# SELECTED BIBLIOGRAPHY

Ades, Dawn, *Dada and Surrealism.* Woodbury, N.Y., 1978.

Bailly, Jean Christophe, *Duchamp.* New York, 1985.

Ball, Hugo, *Flight out of Time: A Dada Diary.* New York, 1974.

Barr, Alfred H., Jr. *Fantastic Art, Dada, Surrealism.* New York, 1947 and 1968.

*Berlin/Hanover, the 1920's.* Dallas Museum of Fine Arts, 1977.

Bigby, C.W. *Dada and Surrealism.* London, 1972.

*Cinquantant'anni a Dada: Dada in Italia, 1916-1966.* Milan, 1966. Text in Italian, French and English.

*Dada in Europa, Werke und Dokumente.* Berlin, 1977.

Elderfield, John, *Kurt Schwitters,* London, 1985.

Duchamp, Marcel, *The Essential Writings of Marcel Duchamp,* edited by Michel Sanouillet and Elmer Peterson, London, 1975.

Foster, Stephen C. and Rudolf E. Kuenzli, eds, *Dada Spectrum: the Dialectics of Revolt.* Madison, Wisc., 1979.

Hülsenbeck, Richard, *Memories of a Dada Drummer.* New York, 1974.

Kuenzli Rudolf E., ed., *New York Dada,* New York, 1986.

Lebel, Robert. *Marcel Duchamp.* New York, 1959.

Lippard, Lucy R., ed., *Dadas on Art.* Englewood Cliffs, N.J., 1971.

Man Ray, *Self Portrait.* Boston, 1963.

Matthews, J.H., *Theatre in Dada Surrealism,* New York, 1980.

Motherwell, Robert, ed. *The Dada Painters and Poets: an Anthology.* New York, 1951.

Penrose, Sir Roland, *Man Ray.* New York, 1975.

Ran, B. *Hans Arp, the Reliefs Catalogue of Complete Work.,* New York, 1981.

Richter, Hans. *Dada Art and Anti-Art.* New York, 1966.

Rubin, William S. *Dada and Surrealist Art.* New York, 1968.

Sanouillet, Michel, *Dada à Paris.* Paris, 1965.

Schmalenbach, Werner, *Kurt Schwitters.* Munich, 1984.

Short, Robert, *Dada and Surrealism.* New York, 1980.

Spies, Werner, *Max Ernst Werke 1905-1925.* Cologne, 1975.

Tzara, Tristan, *Seven Dada Manifestoes.* New York, 1979.

### REVIEWS

*Bleu,* 1 issue, 1921, Mantua, ed. J. Evola.

*Bulletin D,* 1 issue, 1919, Cologne, ed. J. T. Baargeld et M. Ernst.

*Cabaret Voltaire,* 1 issue, 1916, Zurich, ed. H. Ball.

*Cannibale,* 2 issues, 1920, Paris, ed. F. Picabia.

*Club Dada,* 1 issue, 1918, Berlin, ed. R. Hausmann, R. Hülsenbeck

*Dada,* 6 issues, 1917-1920, Zurich-Paris, ed. T. Tzara.

*Der blutige Ernst,* 1 issue, 1919, Berlin, ed. G. Grosz.

*Der Dada,* 3 issues, 1919-1920, Berlin, ed. R. Hausmann.

*Die Pleite,* 6 issues, 1919-1924, Berlin, ed. W. Herzfelde.

*Der Ventilator,* 1 issue, 1919, Cologne, ed. J. T. Baargeld.

*Der Zeltweg,* 1 issue, 1919, Zurich, ed. T. Tzara, W. Serner.

*Die Schammade,* 1 issue, 1920, Cologne, ed. M. Ernst.

*Jedermann sein eigener Fusball,* 1 issue, 1919, Berlin, ed. J. Heartfield, W. Herzfelde.

*La pomme de pin,* 1 issue, 1922, Saint Raphaël, ed. F. Picabia.

*Le cœur à barbe,* 1 issue, 1922, Paris, ed. T. Tzara.

*Littérature,* 1st series : 20 issues; 2nd series: 13 issues, 1919-1924, Paris, ed. A. Breton.

*Maintenant,* 4 issues, 1913-1915, Paris, ed. A. Cravan.

*Mecano,* 4 issues, 1922-1923, Leiden, ed. T. Van Doesburg.

*Merz*, 24 issues, 1923-1932, Hanover,
ed. K. Schwitters.
*New York Dada*, 1 issue, 1921, New York,
ed. M. Duchamp, M. Ray.
*Proverbe*, 6 issues, 1920, Paris,
ed. P. Eluard.
*Rongwrong*, 1 issue, 1917, New York,
ed. M. Duchamp.
*S.I.C.*, 54 issues, 1916-1919, Paris,
ed. P. A. Birot.
*The Blind Man*, 2 issues, 1917, New York,
ed. M. Duchamp.
*Le Pilhaou-Thibaou*, 1 issue, 1921, Paris,
ed. F. Picabia.
*TNT*, 1 issue, 1918, New York, ed. M. Ray.
*291*, 12 issues, 1915-1916, New York,
ed. A. Stieglitz.
*391*, 12 issues, 1917-1924, Barcelona, New
York, Zurich, Paris, ed. F. Picabia.

## 1916

ZURICH

February 5: Opening of the Cabaret Voltaire by Hugo Ball.

March: Performances at the Cabaret Voltaire with poetry readings, dances, masks...
Participants: Jean Arp, Ball, Richard Hülsenbeck, Marcel Janco, Tristan Tzara, Sophie Taeuber...

April: Discovery of the word DADA.

June: Publication of the first (and last) issue of *Cabaret Voltaire*.

July: Dada performance, Zur Waag auditorium. Tzara reads the first Dada manifesto.

July/October: Publication of Tzara's *La première aventure céleste de Monsieur Antipyrine*.

Hülsenbeck's departure for Berlin; arrival of Hans Richter.

PARIS

First issue of the review *SIC*, edited by Pierre-Albert Birot.

BARCELONA

Publication of the first issue of *391*.

NEW YORK

Walter Arensberg, Marcel Duchamp, Man Ray, and Manuel de Zayas found the Society of Independent Artists.

January: Francis Picabia exhibit at the Modern Gallery (managed by de Zayas).

## 1917

ZURICH

January/February: Dada exhibit at the Galerie Corray. Participants: Arp, Janco, Otto Van Rees, Richter.

March/April/May: Opening celebration for the Galerie Dada (formerly the Galerie Corray).

"Sturm" exhibit. Participants: Max Ernst, Wassily Kandinsky, Paul Klee.

Dada performances: "Sturm performance," "Abend neuer Kunst" (Performance of New Art), "Alte und neue Kunst" (Old and New Art).

Lectures by Tzara (Expressionism and

Relâche
1924

Duchamp

Hülsenbeck

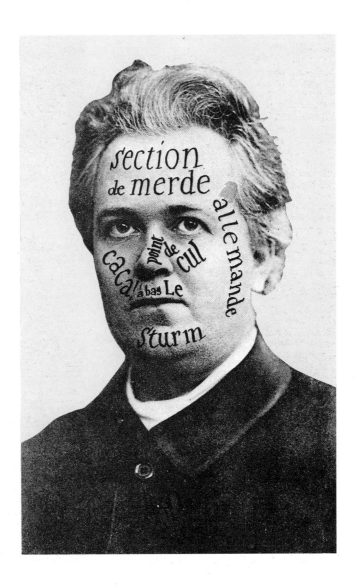

Raoul Hausmann
Postcard sent to Tristan Tzara
1921

Abstract Art) and Ball (Kandinsky).
May: The third Dada exhibit, "Negro Music
and Dance," with the Zurich Dadaists, de
Chirico, Klee, Prampolini.
July: Publication of the first issue of Tzara's
review *Dada*.
NEW YORK
January: Arrival of Arthur Cravan and
Francis Picabia.
May: The first of the two issues of Duchamp's
*The Blind Man*.
The first annual exhibit of the Society of
Independent Artists: Duchamp enters a real
urinal, entitled *Fountain*, which is refused.
June: Publication of the first (and last) issue of
Duchamp's *Rongwrong*.
BERLIN
January: Publication of Hülsenbeck's article
*Der neue Mensch* (New Man) in *Neue
Jugend*.
PARIS
May: First performance of the ballet *Parade*,
with music by Satie and the set by Picasso.
June: Performance of Guillaume Apollinaire's
*Mamelles de Tirésias*.
First issue of the review *Nord Sud*, edited by
Pierre Reverdy.

Picabia
c. 1920

## 1918
LAUSANNE
February: Arrival of Picabia, who meets
Tzara and Arp and publishes *Poèmes et
dessins de la fille née sans mère* and
*L'Athlète des pompes funèbres*.
ZURICH
Publication of Tzara's *25 Poèmes*, with
engravings by Arp, in the "Dada" collection.
Public reading by Tzara of his *1918 Dada
Manifesto*.
September: "Die neue Kunst" exhibit.
Participants: Arp, Janco, Richter.
BASEL
Founding of the "Dada Neue Leben"
association (Arp, Janco, Taeuber).
NEW YORK
Publication of *TNT* (the only issue to appear).
Duchamp leaves New York for Paris.

Figure for
Relâche
1924

Baader

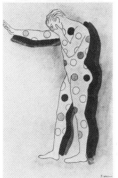

Figure for
Relâche
1924

Soupault

BERLIN
January: An evening of Dada propaganda organized by Hülsenbeck.
April: Founding of the Dada Club with Raoul Hausmann, Hülsenbeck, Mehring. Publication of *Club Dada*. First Dada performance organized by Hülsenbeck. Participants: Hausmann, George Grosz.
October: Hausmann publishes *Material der Malerei, Plastik und Architektur* (The Material of Painting, Sculpture, and Architecture).
December: Johannes Baader creates a scandal by interrupting mass in the Berlin Cathedral.
HANOVER
June: The first Kurt Schwitters exhitit at the Der Sturm gallery in Berlin.
PARIS
Death of Apollinaire.
Death of Jacques Vaché.
MEXICO
Disappearance of Cravan in the gulf of Mexico.

**1919**
ZURICH, GENEVA
January: "Das neue Leben" exhibit.
Lectures by Tzara ("Abstract Art") and Janco ("Abstract Art and Its Goals").
April: Dada performances. Readings of simultaneous poems, manifestoes, music by Arnold Schönberg...
Founding of the Radical Artists group (Arp, Eggeling, Janco, Richter).
Departure of Richter and Eggeling for Berlin.
October: First publication of the review *Der Zeltweg*, edited by Tzara and Serner.
December: Last Dada performance in Geneva.
BERLIN
January: Schwitters and Klee exhibit at the Der Sturm gallery.
February: Publication of the manifesto *Dadaisten gegen Weimar* (The Dadaists Against Weimar).
First publication of the review *Jedermann*

*sein eigener Fusball* (To Each His Own
Football), edited by John Heartfield and
Wieland Herzfelde.
April: Publication of the first issue of *Die
Pleite*.
May: First Dadaist exhibit in Berlin.
June: Publication of the first issue of *Der
Dada*, edited by Hausmann.
September: Publication of the first and last
issue of *Der blutige Ernst* (Bloody
Seriousness).
COLOGNE
Ernst and Baargeld found the Rhineland
Dada Conspiracy. Publication of the review
*Bulletin D*, edited by Ernst and Baargeld, and
of *Der Ventilator*, edited by Baargeld.
Publication of Ernst's *Fiat Modes*.
HANOVER
June/September: Exhibition of Schwitters'
first "Merz."
PARIS
March: Publication of the first issue of the
review *Littérature*, edited by Aragon, Breton,
and Soupault.
July: The first contacts between Duchamp,
Picabia, and the Parisian Dadaists.
October: Publication in *Littérature* of extracts
from Breton and Soupault's *Champs
magnétiques*.

**1920**
NEW YORK
Duchamp (back from Paris), Man Ray, and
Katherine Dreier found the Société anonyme.
BERLIN
Hülsenbeck publishes *En avant Dada*.
February: Dada tour with Baader, Hausmann,
Hülsenbeck (Dresden, Leipzig, Prague).
Publication of the *Dada Almanach*.
June: 'Erste Internationale Dada Messe," an
exhibit which brings together the Berlin
Dadaists and Otto Dix, Rudolf Schlichter,
Georg Scholz, Picabia, and Ernst (Burchard
Gallery).
PARIS
January/February: Arrival of Arp and Tzara

Schwitters

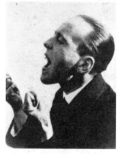

Heartfield

Janco

Man Ray

Dix

Arp

in Paris. Series of Dada activities: "Vendredis de Littérature," at the Salon des Indépendants, the Club du faubourg, and the Salle Gaveau. Exhibits at the Au Sans Pareil gallery: Picabia, Ernst, Ribemont-Dessaignes...

May: Exclusion of the "Dadas" from the Section d'Or. Publication of *Cannibale* by Picabia. Publication of the first issue of the review *Proverbe* by Paul Éluard. Special issue of *Littérature* with 21 Dada Manifestoes.

June/July: Publication of *Cinéma calendrier du cœur abstrait* (Tzara) and *Jésus Christ Rastaquouère* (Picabia).

August: Publication in the NRF of Breton's article "Pour Dada" and of Jacques Rivière's essay "Reconnaissance à Dada."

COLOGNE

February: Publication of the review *Die Schammade*.

Dada exhibit (Arp, Ernst, Baargeld) closed by the police.

**1921**

NEW YORK

The last Dada activities: Publication of *New York Dada*, edited by Duchamp and Man Ray.

BERLIN

Lawsuit against the Berlin Dadaists Herzfeld, Grosz, and Schlichter.

September: Tour and "Merz and anti-Dada" perfomances (Prague) organized by Hausmann, Hannah Höch, and Schwitters. Grosz breaks with Dada.

PARIS

Announcement of "the great Dada season": visits, Dada salon, congress, commemorations, operas, plebicites, requisitions, accusations and judgments. During the "Barrès trial," Picabia breaks with the movement. Tzara's criticism. Dada Salon participants: Arp, Man Ray, Duchamp, and the Parisian Dadaists (Galerie Montaigne). Man Ray and Ernst exhibits (Galerie Au Sans Pareil).

Picabia publishes the *Pilhaou-Thibaou* in

which he violently attacks Dada.
ITALY
Publication of the review *Bleu*, edited by
Julius Evola.

## 1922
WEIMAR
September: Constructivism-Dada Congress.
PARIS
Failure of the project for an "International
Congress for the Determination of Directives
and the Defense of the Modern Spirit";
break-up of Dada, Breton/Tzara polemics.
Picabia continues his attacks on the Dadaists
in *La pomme de pin*.
Publication of the first issue in the second
series of the review *Littérature*, edited by
Breton.
HOLLAND
Van Doesburg publishes the review *Mecano*
under the pseudonym I. K. Bonset.
HANOVER
September: Dada show organized by
Schwitters with Arp, Hausmann, Tzara, and
van Doesburg at the von Garvens gallery.
Schwitters, Grosz exhibit at the von Garvens
gallery.

## 1923
PARIS
July: last organized Dada activities in Paris,
"Cœur à barbe" evening organized by
Tzara (a film by Richter, music by Satie, and a
performance of Tzara's *Cœur à gaz*)
provoking the hostile reaction of Breton and
his friends.
HANOVER
Publication of the first issue of the review
*Merz* by Schwitters. Schwitters' trip to
Holland, where he gives a series of public
performances.

## 1924
PARIS
Publication of Tzara's *Sept Manifestes dada
Lampisteries* (Seven Dada Manifestoes
Lampstores) with drawings by Picabia.

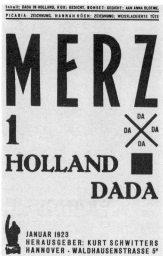

Top:
Richard Hülsenbeck
Phantastische Gebete
1916

Bottom:
Kurt Schwitters,
Cover of Merz, no. 1
1923

# FRANCIS PICABIA

EST UN IMBÉCILE, UN IDIOT, UN PICKPOCKET !!!

MAIS

IL A SAUVÉ ARP DE LA CONSTIPATION !

LA PREMIÈRE ŒUVRE MÉCANIQUE A ÉTÉ CRÉÉE PAR MADAME TZARA LE JOUR OÙ ELLE MIT AU MONDE LE PETIT TRISTAN, ET POURTANT ELLE NE CONNAISSAIT PAS

# FUNNY-GUY

# FRANCIS PICABIA

est un professeur espagnol imbécile,

qui n'a jamais été dada    FRANCIS   PICABIA  N'EST   RIEN !

# FRANCIS PICABIA AIME LA MORALE DES IDIOTS

LE BINOCLE DE ARP EST UN TESTICULE DE TRISTAN

# FRANCIS PICABIA N'EST RIEN !!!!

EST PAUVRE
EST RICHE
N'EST PAS SÉRIEUX
EST UN PROFESSEUR
EST UN ESPAGNOL
EST UN IMBÉCILE
N'EST PAS UN LITTÉRATEUR
N'EST PAS UN PEINTRE
EST UN CLOWN
EST UN IDIOT
EST UN LOUSTIC

FRANCIS PICABIA

MAIS : ARP ÉTAIT DADA AVANT DADA

BINET-VALMER AUSSI
RIBEMONT-DESSAIGNES AUSSI
PHILIPPE SOUPAULT AUSSI
TRISTAN TZARA AUSSI
MARCEL DUCHAMP AUSSI
THÉODORE FRAENKEL AUSSI
LOUIS VAUXCELLES AUSSI
FRANTZ JOURDAIN AUSSI
LOUIS ARAGON AUSSI
PICASSO AUSSI
DERAIN AUSSI
MATISSE AUSSI
MAX JACOB AUSSI
ETC... ETC... ETC.....

EXCEPTÉ FRANCIS PICABIA

LE SEUL ARTISTE COMPLET !

# FRANCIS PICABIA VOUS CONSEILLE D'ALLER VOIR SES TABLEAUX AU SALON D'AUTOMNE,

ET VOUS PRÉSENTE SES DOIGTS A BAISER.

FUNNY-GUY.

Les hommes couverts de croix font penser à un cimetière

Si vous voulez avoir les idées propres changez-en comme de chemises

Tract by Francis Picabia
handed out at the Salon d'Automne
1921

Publication of the first manifesto of Surrealism. Picabia's ballet *Relâche*, music by Satie. Last issue of *391*.

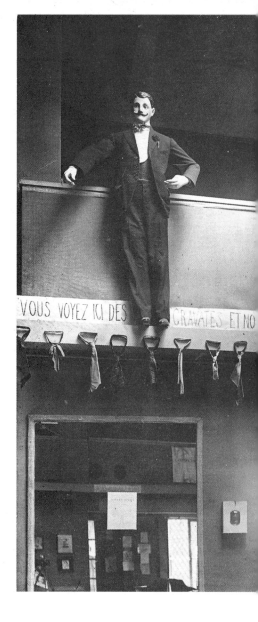

Dada exhibition
in Paris
1921

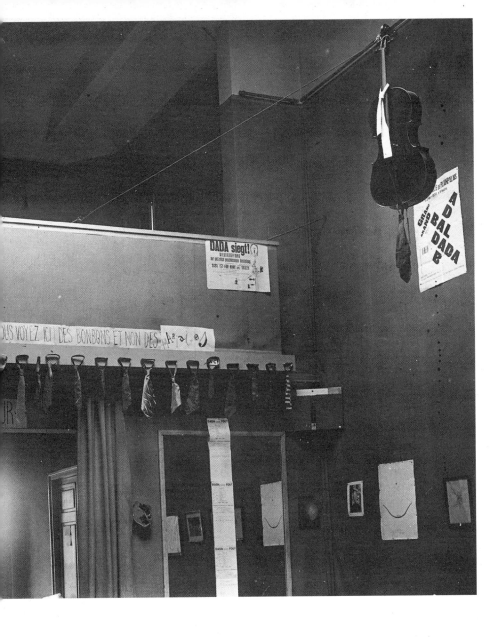

(Les Signataires de ce manifeste habitent la France, l'Amérique, l'Espagne, l'Allemagne, l'Italie, la Suisse, la Belgique, etc., mais n'ont aucune nationalité).

# DADA SOULÈVE TOUT

## DADA connaît tout. DADA crache tout.

## MAIS.......

*DADA VOUS A-T-IL JAMAIS PARLÉ :*

**OUI = NON**

**OUI = NON**

**OUI = NON**

de l'Italie
des accordéons
des pantalons de femmes
de la patrie
des sardines
de Fiume
de l'Art (vous exagérez cher ami)
de la douceur
de d'Annunzio
quelle horreur
de l'héroïsme
des moustaches
de la luxure
de coucher avec Verlaine
de l'idéal (il est gentil)
du Massachussetts
du passé
des odeurs
des salades
du génie . du génie . du génie
de la journée de 8 heures
et des violettes de Parme

## JAMAIS JAMAIS JAMAIS

DADA ne parle pas. DADA n'a pas d'idée fixe. DADA n'attrape pas les mouches

# LE MINISTÈRE EST RENVERSÉ. PAR QUI ? PAR DADA

**Le futuriste est mort. De quoi ? De DADA**

Une jeune fille se suicide. A cause de quoi ? De DADA

On téléphone aux esprits. Qui est-ce l'inventeur ? DADA

**OUI = NON**

On vous marche sur les pieds. C'est DADA

Si vous avez des idées sérieuses sur la vie,

Si vous faites des découvertes artistiques

et si tout d'un coup votre tête se met à crépiter de rire,

si vous trouvez toutes vos idées inutiles et ridicules, sachez que

# C'EST DADA QUI COMMENCE A VOUS PARLER

'' Dada soulève tout ''
Paris, 1921

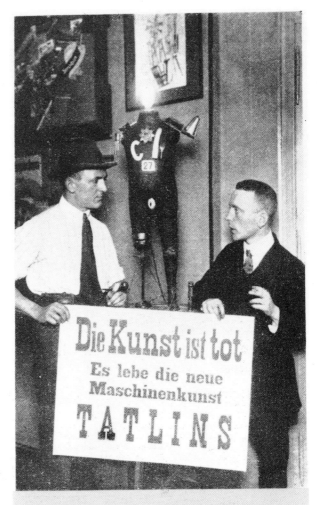

Die Kunst ist tot
Es lebe die neue
Maschinenkunst
TATLINS

**George Grosz** (links) und **John Heartfield** (rechts) demonstrieren gegen die Kunst zugunsten ihrer Tatlinistischen Theorie

George Grosz
and John Heartfield
1920

# ILLUSTRATIONS

1920, watercolor and India ink. Galerie Nierendorf, Berlin.

51 : Top: Grosz and Heartfield, *Life and Movement in Universal City at 12:05 Noon* (or *Dada Fox*), 1919-1920, collage and drawing. The original is lost.
Bottom: Heartfield, *10 Years After: Fathers and Sons*, 1924, photograph of a photomontage. Heartfield Archives, East Berlin.

53 : Arp and Lissitzky, p. 2 of the book *Die Kunstismen*, Zurich, 1925.

58 : Top left: Schwitters, *Merz 600 Leiden*, 1923, collage. Kunsthalle, Hamburg.
Top right: Schwitters, *Separated Forces*, 1920, assemblage. Kunstmuseum, Bern.
Bottom: Schwitters, *Mz 231 Miss Blanche*, 1923, collage. Werner Schmalenbach Collection, Düsseldorf.

59 : Schwitters, *Merzbild Kijkduin*, 1923, assemblage. Thyssen-Bornemisza Collection, Lugano.

60 : Top left: photograph of *The Holy Affliction*, 1920, assemblage, with Kurt Schwitters in his studio.
Top right: Schwitters, *Merzbau*, photograph from 1928.
Bottom left: Schwitters, *ppppp... Pornographisches i-Gedicht*, in *Merz*, no. 2, Hanover, 1923.
Bottom right: Schwitters, *Gesetztes Bildgedicht*, 1922.

61 : Schwitters, *Mz 391 Pinakothek*, 1922, collage. Artist's estate, Malborough Gallery, London.

63 : Arp and Ernst, *Physiomythologisches diluvialbild* (Fatagaga), 1920, collage. Dieter Brusberg Gallery, Hanover.

66 : Ernst, *Dada-Degas*, 1920-1921, collage, Bayerische Staatsgemäldesammlungen, Neue Staatsgalerie, Munich.

67 : Ernst, *1 Kupferblech, 1 Zinkblech, 1 Gummituch, 2 Tastzirkel*, c. 1920. The work is missing.

69 : Picabia, *The Cacodylic Eye*, 1921, oil and collage. Centre Georges Pompidou, Musée national d'art moderne, Paris.

71 : Picabia, *Dance of Saint Guy*, 1919-1920, frame, string, and cardboard. Photograph of Picabia at the Salon d'Automne in 1922. Bibliothèque littéraire Jacques Doucet, Paris.

72/73 : Contributors to the review *391* in 1921. First row: Tzara, Céline Arnauld, Picabia, Breton. Second row: Peret, Dermée, Soupault, Ribemont-Dessaignes. Third row: Aragon, Fraenkel, Eluard, Pansaers, Fay.

74 : Man Ray, *Gift*, 1921, metal. Morton Neumann Collection, Chicago.

75 : Picabia, cover of the review *391*, no. V, 1, June 1917, "Ane." Bibliothèque littéraire Jacques Doucet, Paris.

77 : Soupault, *Cité du Retiro*, 1921, tar and frame, Musée d'art moderne de la ville de Paris.

79 : Top left: Duchamp, *Rotary Glass Plates,* with Man Ray, motorized construction. Yale University Art Gallery, New Haven.
Top center: Duchamp, *L.H.O.O.Q.*, adjusted ready-made (pencil on reproduction).
Top right: cover of *Le Coeur à barbe*, Paris, April 1922, no. 1. Bibliothèque littéraire Jacques Doucet, Paris.
Bottom left: Picabia, photograph of André Breton at the Théâtre de l'Oeuvre, Paris, 1920. Bibliothèque littéraire Jacques Doucet, Paris.
Bottom right: Duchamp, *Why not Sneeze Rrose Sélavy ?*, 1921, assisted ready-made (metal, marble, thermometer, cuttlebone). Philadelphia Museum of Art.

81 : Ernst, *Two Children Are Threatened by a Nightingale*, 1924, oil, assemblage with frame. Museum of Modern Art, New York.

82 : Ernst, *The Punching Ball or the Immortality of Buonarroti*, 1920, photomontage and gouache.

83 : Moholy-Nagy, *Die Grosse Gefühlsmaschine*, 1920, oil. Stedelijk van Abbemuseum, Eindhoven.

84 : *Anthologie Dada*, cover, Zurich, 1919. Kunsthaus, Zurich.

85 : Photograph of Tristan Tzara.

86 : Schad, *Transmission*, 1919, oil on canvas. Kunsthaus, Zurich.

87 : Höch, *New York*, c. 1922, collage. Nationalgalerie, Berlin.

88/89 : Duchamp, *Dust Farm*, 1920. Photograph by Man Ray. Yale University Art Gallery, New Haven.

90 : Photograph of Francis Picabia.

## PHOTO CREDITS

Akademie der Künste der DDR: 51b
Bibliothèque nationale, Paris: 110b, 114
Thyssen-Bornemisza Collection, Lugano: 44, 58c
Edimedia: 72-73
Hubert Josse: 17, 49, 71, 75, 79c, 79d, 96-97
Kunsthaus, Zurich: 15, 21b, 25, 27a, 27c, 84, 86
Kunstmuseum, Basel: 21d
Musée national d'art moderne, Paris: 21a, 24a, 39a, 39b, 39c, 45c, 91
Peter Lauri: 58b
Ralph Kleinhempel: 58a
Roger-Viollet: 77, 85, 107c, 112-113
Staatsgalerie, Stuttgart: 46
Yale University Art Gallery, New Haven: 31a

For their kindness
in reading
my manuscript and
for their helpful
suggestions, I would
like to thank
Hans Bolliger and
Marianne Le Pommeré.